古今對話 — 中西互鑒

現當代中國藝術家名品珍賞

TRADITION AND MODERNITY

Representative Works by
Modern and Contemporary Chinese Artists

主編　焦天龍

知名當代藝術家
RENOWNED CONTEMPORARY ARTISTS

目錄

現代藝術大師
MASTERS OF MODERN CHINESE ARTS

CONTENTS

序一

鄭志剛

非常榮幸爲各位帶來「藝文香港 ART HONG KONG」這個慶祝香港特別行政區成立 25 周年的藝術展覽及一系列活動。

2021 年，中央人民政府在《十四五規劃綱要》明確支持香港發展成爲「中外文化藝術交流中心」，爲香港的文化事業指明了發展方向。自此，香港的文化事業有了國家政策作爲後盾，無疑對香港文藝事業的發展打了一劑強心針，令業界人士備受鼓舞。特區政府隨即在 2021 年《施政報告》中明確指出，香港將循五大方向落實文化新定位，包括加強與內地及海外的文化交流 ──「藝文香港 ART HONG KONG」正是在這樣的大背景下應運而生。作爲一名投身文化產業多年的企業家，我能夠參與其中，爲香港的文化藝術事業發展略盡綿力，與有榮焉。

我深信藝術文化是一種可以超越時空的語言，是人類重要的精神資產，所以我一直盡自己所能，推動年輕一代認識、欣賞更多。2008 年，我創立了 K11 品牌，首倡「博物館零售」概念，將藝術文化注入商業零售，爲全球千禧世代及 Z 世代建構「文化矽谷」。經過十多年的發展，K11 品牌除了拓展至零售、酒店、服務式公寓、寫字樓等領域外，更延伸到文化藝術推廣、工藝傳承、文藝人才培育等範疇。K11 旗下的兩家非牟利機構，目前正積極朝着這些方向邁進：2010 年，我成立了 K11 Art Foundation，爲首間扶植中國藝術家及策展人的非牟利機構；K11 Craft & Guild Foundation 於 2019 年成爲香港註冊的藝術及文化慈善機構，致力傳承與復興即將失傳的中國傳統工藝，包括廣彩、百寶嵌、螺鈿、描金、灰塑、木建築、緙絲、紅樓夢，並旨於建立非物質文化遺產生態圈，爲社會創造共享價值。此外，我在 2007 年成立中華青年精英基金會，通過舉辦交流活動、青年論壇、調研實踐等項目，增強香港與內地以至海外青年的交往交融，致力培育青年在藝術修養、人文素養、實踐創新及國際視野等方面的才能，促進中國青年攜手在國際舞台展現中國力量，說好中國故事。

經過十多年的耕耘，加上多位同行前輩的努力，香港的藝術文化事業已漸見成熟，藝術與文化逐步融入大眾生活。受益於這個大趨勢，K11 如今亦成功開創出一種「藝文商社」共融的發展模式，將藝術、文化、商業、社會四個看似互不相干的元素，聯繫成一個個互助相長的夥伴。

而在「藝文香港 ART HONG KONG」的策劃過程中，「共融」理念同樣貫穿其中。我們這次希望呈現的，不只是一場單純的藝術展覽，我們還希望「藝文香港 ART HONG KONG」能成爲一個標誌性的藝術盛事，讓其躋身國際頂尖文化藝術盛會之列，爲香港未來的文化藝術發展路向，帶來多一點啟發。

是次活動的重頭戲 ──「現當代中國藝術家名品展」的主題爲「古今對話 中西互鑒」。所謂「古今對話」，是以當代藝術的角度去重新探索傳統經典藝術的風采，通過多元化的藝術形式去詮釋箇中意

涵，為觀眾帶來嶄新的視覺與知性體驗；「中西互鑒」則是以當代藝術的表現形式，探討西方藝術對中國當代藝術的影響，推動海內外藝術家與世界文化藝術產業的對話，共同思索香港日後在國際文化藝術發展能夠發揮的作用。

這次展覽中，我們很榮幸可以展出吳冠中、林風眠、徐悲鴻、陳樹人、傅抱石、齊白石六位現代藝術大師的作品，並邀請到了八位蜚聲國際的中青代中國藝術家：王天德、林天行、郝量、張恩利、章燕紫、梁遠葦、劉建華和謝曉澤。在「古今對話 中西互鑒」這個主題下，他們的作品將以不同的創作形式和藝術語言呈現：王天德是前衛水墨畫的開創者之一，他獨創的燒燻水墨畫，以燃燒的香支與墨在宣紙上作畫，開創了極具感染力的新水墨風格；林天行以創新思維開拓了水墨重彩的新領域，在斑斕的色塊中體現當代的水墨意味，同時不失中國筆墨的神韻；郝量則以其獨有方式，糅合中國古典寫實的傳統工筆與西方文藝復興濕壁畫的視覺效果，將中華經典用當代水墨語言呈現給觀眾；張恩利擅於體現創作風格鮮明、具獨立性的作品，其畫作多以刻劃生活日常，避免符號化的語言，讓觀眾跟着他的色彩與線條一起回歸繪畫的本質；章燕紫以她具備獨特風格的作品，在悠久的中國歷史文化與多變的當代藝術之間建起了一座橋，讓觀者可以在古今對照之間汲取到中國優秀傳統的精髓；梁遠葦精於繪畫、攝影、雕塑及裝置藝術多個範疇，她的作品以精細、繁複、耗時見稱，將一絲不苟的工匠精

神展現得淋漓盡致；劉建華的創作涵蓋陶瓷和綜合材料作品，以創新的方式反映近年來社會經濟發展的變化；謝曉澤通過別具一格的視角探尋歷史，從敦煌藏經洞、佛教宇宙觀及但丁的《神曲》中汲取靈感，以獨特的創作手法為觀眾呈現中西方文化的對話、呼應、折衷和轉換。為配合展覽，我們還舉辦了藝術工作坊及大師班，為公眾提供參與、體驗藝術創作的機會，讓藝術更加貼近生活。

不僅如此，我們在展覽期間舉辦五場論壇，邀請業界重量級嘉賓討論三個主題：「傳統與中國當代藝術」、「從博物館的視角看中西文明的互動與交流」，以及「香港藝術市場的發展趨勢」。通過論壇，讓香港的文藝界人士和一眾藝文愛好者從不同角度深入了解香港文藝事業的發展願景。另外，在文化藝術教育方面，我們與擁有「天下第一名社」之稱的西泠印社攜手，跟其在港獨家授權機構——西泠學堂，合作策劃「西泠盃」全港青少年書畫篆創作大賽及大賽優秀作品展，以及西泠學堂工作坊及大師班，多管齊下推廣中國傳統文化，讓更多香港年輕一代感受到傳統文化藝術的魅力。

最後，我希望藉此機會感謝活動的主辦機構紫荊文化集團；承辦機構集古齋；協辦機構香港故宮文化博物館、聯合出版集團、中國對外文化集團；支持機構古物古蹟辦事處、香港中國企業協會、《紫荊》、銀都機構有限公司、香港聯藝機構有限公司、香港文聯、香港書畫文玩協會、中國對外藝術展覽

有限公司、《明報月刊》、《美術家》、西泠學堂。特別感謝參展藝術家王天德、林天行、郝量、張恩利、章燕紫、梁遠葦、劉建華和謝曉澤，以及所有參與論壇的主持和講者。當然，一切活動能夠順利舉行，一眾不辭勞苦的工作人員功不可沒——我在此向各位衷心致謝。

回歸 25 年來，香港的城市氣質已經發生了翻天覆地的變化，文化藝術已成為大眾生活的一部分。我們殷切希望通過各方努力，「藝文香港 ART HONG KONG」能借助國家「十四五」規劃的東風，蛻變成一個具備「國際品牌、中國氣派、香港特色、紫荊影響」的藝術盛會，為香港建設成「中外文化藝術交流中心」作出貢獻！

「藝文香港 ART HONG KONG」策略規劃委員會主席
鄭志剛
2022 年 11 月 1 日

Foreword I

ADRIAN CHENG

I am deeply honoured to present the ART HONG KONG exhibition and a series of collateral events in celebration of the 25th Anniversary of the Establishment of the Hong Kong Special Administrative Region (HKSAR).

In 2021, the Central People's Government of the People's Republic of China declared its clear support towards Hong Kong's development into an "East-meets-West centre for international cultural exchange" in the *14th Five-Year Plan*, laying down the roadmap for the city's future cultural undertakings. Backed by national policy, Hong Kong's art and cultural industries have been given a boost of confidence, and those working in the sector have been greatly motivated. The HKSAR Government declared a five-pronged action plan in its 2021 Policy Address to realise Hong Kong's new cultural positioning, one of them being the enhancement of cultural exchange and co-operation with Mainland China and the rest of the world. It is against these inspiring recent developments that I proudly announce the ART HONG KONG exhibition. As an entrepreneur who has been active in the cultural industry for many years, I am honoured to participate in the exhibition and to contribute to Hong Kong's cultural and artistic endeavours.

I believe that art is a language that transcends time and space. It is one of humanity's greatest spiritual assets. That explains why I always encourage the younger generation to learn and appreciate art. In 2008, I founded the K11 brand, developed the concept of "museum retail" that infused art into commercial retail, and built the "Silicon Valley of Culture" for millennials and the global Generation Z. After more than ten years of development, the K11 brand has expanded to encompassing retail, hotels, serviced apartments, office buildings, cultural and artistic promotion, art and craft preservation, and incubating artistic talents. Meanwhile, two non-profit organizations under K11 are actively spearheading various initiatives in the aforementioned directions - In 2010, I established the K11 Art Foundation, the first non-profit organization that supports Chinese artists and curators; while in 2019, K11 Craft & Guild Foundation (KCG) was registered as a charitable institution of arts and culture in Hong Kong. KCG conserves and rejuvenates fast-disappearing Chinese artisanship, namely Guangcai, Baibaoqian, Luodian, Gilt-decoration, Plaster Moulding, Wooden Architecture, Kesi, *Dream of the Red Chamber*, creating a craft ecosystem with sustainable social impact. In an effort to encourage dialogue and exchange between young people in Hong Kong, Mainland China and beyond, I established the China Youth Leaders Foundation in 2007, through which various cross-cultural initiatives such as exchange activities, youth forums, research and practical projects, to name but a few, have been organized. The Foundation strives to promote artistic literacy, humanistic qualities, innovation and global vision among the younger generation, and is committed to showcasing the talent of China's youth on the international stage to tell the China story well.

After over ten years of hard work supported by peers, colleagues, and predecessors, Hong Kong's art and cultural scene witnessed strides of progress. Art and culture have become increasingly integrated into everyday life. Benefiting from this new societal shift, K11 succesfully spearheaded our unique "art-culture-commerce-society" development model which integrates the four separate sectors into a seamless holistic entity. Under this integrative model, each disparate segment becomes mutually beneficial to one another.

This integrative model is also embedded in the curatorial direction of ART HONG KONG. Striving to create more than just another art exhibition, we endeavour to mount a marquee show which hopefully will grow into one of the leading international art events which serves to inspire the future development of art and culture in Hong Kong.

The highlight for ART HONG KONG is the exhibition on the Representative Works by Modern and Contemporary Chinese Artists, the theme of which is "Tradition and Modernity". Through the conversation between the old and the new, we revisit the charm of traditional art and the classics through the lens of contemporary art. Re-interpreting the meaning of the classics through diverse contemporary art forms, the audiences will be presented with new visual and intellectual experiences. As for cross-referencing the East and the West, we discuss how Western art has influenced contemporary Chinese art over the years,

and promote dialogue between global artists and the art and cultural industry, exploring together how Hong Kong might contribute to the future growth of global art and culture.

While we are very honoured to be able to present six modern Chinese masterpieces by Chen Shuren, Fu Baoshi, Lin Fengmian, Qi Baishi, Wu Guanzhong and Xu Beihong, we are also very excited to be joined by eight world-renowned emerging and established Chinese artists, namely: Hao Liang, Lam Tianxing, Liang Yuanwei, Liu Jianhua, Wang Tiande, Xie Xiaoze, Zhang Enli, and Zhang Yanzi. Responding in various ways to the curatorial theme, their works span different creative media and artistic languages. Hao Liang combines traditional Chinese fine brushwork with the aesthetics of Renaissance fresco, re-interpreting the Chinese classics with his own unique ink-wash techniques. Lam Tianxing expands the frontiers of ink painting with resplendent colour fields that still preserve the spirit and charm of Chinese ink and calligraphy. Liang Yuanwei demonstrates her signature artistry across diverse media of painting, photography, sculpture, and installation, creating works defined by process, labour, and meticulous craftsmanship. Liu Jianhua's ceramic and mixed media works comment on social and economic developments in innovative ways, earning him acclaim as one of the most experimental and representative artists in China today. An important forerunner in avant-garde ink-wash painting, Wang Tiande's inventive method of using burning incense

sticks onto xuan paper pioneered a powerful new aesthetics in the contemporary ink vernacular. Xie Xiaoze explores history from a unique perspective – he draws inspiration from Dunhuang Library Cave, Buddhist Cosmology and the Italian poet Dante Alighieri's *The Divine Comedy* to create works that present interactions between the Eastern and Western cultures. Zhang Enli's distinctive, idiosyncratic works avoid symbols and metaphors, drawing audiences back to the pure essence of art by depicting the simple poetry of everyday life. Finally, Zhang Yanzi concocts a unique bridge linking antiquity and contemporaneity, igniting reflection on the essence of Chinese history and culture. Workshops and master classes will be held in parallel to the exhibition, providing opportunities for the public to participate in and experience the process of artistic creation, drawing art one more step closer to life.

In addition, five forums will be held alongside the exhibition. Authoritative speakers from relevant sectors will speak on three topics, namely: "Traditional and Contemporary Chinese Art", "The Interaction and Exchange Between Chinese and Western Civilisations: A Museological Perspective", and "The Hong Kong Art Market: History, Development and Future". These forums will facilitate widened perspectives and a deepened understanding of the developmental vision of Hong Kong's art and cultural undertakings amongst the art and culture circle and art connoisseurs in general.

In regard to artistic and cultural education, we are honoured to join hands with Hong Kong Xiling School founded by the renowned Xiling Seal Engraver's Society, also known as the *The First Cultural Society in the World*, to host the "Xiling Cup – Hong Kong Youth Calligraphy, Painting and Seal Engraving Competition". Its accompanying winner's exhibition, as well as art and cultural workshops for youth, implement a multi-faceted approach to promote traditional Chinese art and culture to the younger generation in Hong Kong.

Finally, I would like to thank the organizer of the event, the Bauhinia Culture Group. I also extend my thanks to our fellow co-organizer, Tsi Ku Chai; Organising Partners, the Hong Kong Palace Museum, Sino United Publishing (Holdings) Limited and China Arts and Entertainment Group Ltd; the supporting organizations - Antiquities and Monuments Office, The Hong Kong Chinese Enterprises Association, *Bauhinia* Magazine, Sil-Metropole Organization Ltd, Hong Kong United Arts Entertainment Co., Ltd, Hong Kong Federation of Literary and Art Circles Hong Kong Member Association, Hong Kong Fine Art and Antiques Society, China International Exhibition Agency, *Ming Pao Monthly*, *Artist* Magazine, Xiling School. A special thanks as well to the participating artist Hao Liang, Lam Tianxing, Liang Yuanwei, Liu Jianhua, Wang Tiande, Xie Xiaoze, Zhang Enli, and Zhang Yanzi, as well as all the forum moderators and speakers for their full support. Last but not least, I am deeply grateful to all the organising staff, as the smooth execution of all

events could not have been achieved without their hard work and dedication.

Hong Kong has undergone enormous changes since the handover 25 years ago, whereby art and culture has become part and parcel of everyday life. With the blessing of the *14th Five-Year Plan*, we aspire for ART HONG KONG to blossom into a world-renowned exhibition with the status of a global festival, backed by the power of the Central People's Government, and stamped with the unique Bauhinia identity of the city of Hong Kong, ultimately contributing to the nation's vision of the city as an "East-meets-West centre for international cultural exchange".

Adrian Cheng

Chairman of the Strategies and Planning Committee of ART HONG KONG

November 1, 2022

序二

焦天龍

錢鍾書先生在論述中國畫的發展歷程時，曾經有一段關於藝術風氣的論述：「一個藝術家總是在某些社會條件下創作，也總會在某種文藝風氣裏創作。這個風氣影響到他對題材、體裁、風格的取捨，給與他以機會，同時也限制了他的範圍，就是抗拒或背棄這個風氣的人也受到它負面的支配，因爲他不得不另出手眼來逃避或矯正他所厭惡的風氣。」[1] 換一種說法，藝術風氣也就是藝術的當代性的一個折射，是一個時代的藝術風格的表現。一種藝術風氣的形成受制於多種因素，有歷史的傳統，有社會的認可，也有藝術家個人或群體的探索，而且風氣是不斷變化的。任何一種具有生命力的藝術風氣都是具有當代性的，隨着時間的推移，這些當代的藝術也會變成傳統。不同時代的藝術當代性，就構成了藝術史長河中引人注目的浪花。

傳統在中國藝術的發展過程中，一直是一個具有強大支配作用的力量。但是，中國藝術的發展軌跡不是傳統的簡單延續，而是在不斷地創新。開創元代藝術風氣的趙孟頫，自稱其藝術的靈感源泉和模仿對象是唐代的大師，並以自己的畫馬技術和意境不亞於唐代的韓幹而沾沾自喜。但趙孟頫開創的藝術風氣絕對不是唐代的翻版，而是具有元朝當代性的藝術風格。他所追求的以隱居爲畫意的山水畫風格，建立了一個新的範式，其影響超出元代，直至後世。明末的董其昌在梳理中國繪畫史的南北傳統之後，呼籲並身體力行地摹仿古代大師的筆意。但董其昌更注重的是師古求變，所以他的藝術風格是

不拘泥於歷史上任何一個派別的，其眞正意圖是轉化古人風格，並開創一個新的藝術風氣。對董其昌而言，所有的古代山水畫典範，都是藝術家對造化的一種領悟，超越任何外在的山水奇景，這種超越性的畫意就是他所倡導的藝術風格。董氏由此開創一代新畫風，並持續影響有淸一代。中國藝術的發展軌跡表明，當傳統變成藝術靈感的源泉而不是制約創造力的框架，新的藝術風格就會產生，並變成後世仰慕的新傳統。

晚淸特別是五四以來，傳統與外來的藝術思潮彼此迴旋激蕩、交叉往復，開啟了中國藝術的現代性新篇章。來自西方的藝術在中國掀起了巨大的波瀾，趨之者視爲中國藝術之救星，惡之者視爲中國藝術傳統之災難，而更多的人則呼籲兼採中西之長，探索新的藝術之路。數代中國藝術青年負笈東西洋，虔誠地學習西方藝術，積極探索中國藝術的創新之路，開創了中國藝術發展的新篇章。

在如何振興中國藝術這一問題上，當時的爭論是激烈的。康有爲在感歎「中國近世之畫衰敗極矣」之後，將罪過歸於元代以來的文人畫，認爲中國畫的復興之路是恢復宋畫的寫實風格，並旁及西洋畫法。在這一點上，康有爲和趙孟頫、董其昌有相似之處，皆向傳統找出路。但是，陳獨秀則主張徹底的「藝術革命」。1918 年，他在《新青年》雜誌上發文，斷然提出中國畫要想改良，就必須革以寫意爲中心的文人畫的命：「因爲要改良中國畫，斷不

能不採用洋畫寫實的精神」,「畫家也必須用寫實主義,才能夠發揮自己的天才,畫自己的畫,不落古人的窠臼」。陳獨秀和康有爲的觀點一致,將自元代以來的文人畫稱爲「一派中國惡畫」。這位新文化運動的領軍人物,其改革中國畫的觀點是激進的,徹底否定傳統。康、陳的這些主張在二十世紀初的中國造成了深刻的影響,並激勵了衆多中國畫家把目光投向海外,尋找中國藝術的新道路。

不過,很多畫家眞正在海外學習並接觸了西方藝術之後,探索的卻是將中外長技相結合的道路。留學日本並開創了「嶺南派」的高劍父,就主張:「對於繪畫,要把古今中外的長處折衷地和革新地整理一過,使之合乎中庸之道,所謂集世界之大成……新國畫是綜合的、集衆之長的、眞美合一的、理趣兼到的;有國畫的精神氣韻,又有西畫之科學技法。」[2]在繪畫實踐中,高劍父也是這麼做的。他將中國畫的筆墨傳統與日本畫描繪光、色和空氣的技法結合起來,從而開創了一個新的藝術風格和流派卽「嶺南派」,並一直影響至今。

曾經在 1933-1935 年留學日本的藝術家傅抱石,也積極汲取了當時日本畫的新技巧。他呼籲中國畫不能一成不變,而是應該集東洋和西洋畫的優點,消化之後,爲我所用。代表傅抱石畫法特色的以散鋒用筆爲皴的技法,就是受到了日本畫的影響。這個中國現代美術史上著名的「抱石皴」,使傅抱石成爲「新金陵畫派」的開創者。

留學法國的林風眠(1900-1991)也是主張調和中西藝術中關於情感的抒發和藝術形式的共同點。1926年,林風眠在〈東西藝術之前途〉一文中,表達了他對東西方藝術之異同點的看法:「西方藝術是以模仿自然爲中心,結果傾向於寫實的一面。東方藝術是以描寫想像爲主,結果傾向於寫意的一面。藝術之構成,是由人類情緒上之衝動,而需要一種相當的形式以表現之。前一種尋求表現的形式在自身之外,後一種尋求表現的形式在自身之內,方法之不同而表現在外部之形式,因趨於相異。」[3]他認爲在「科學方法」上,中西藝術是相似的,其區別在於寫實和寫意,表現的形式不同。他由此而倡導「調和中西藝術」,並身體力行,開創了獨特的藝術風格。1928 年,林風眠出任中國第一所美術高校國立藝術學院院長,爲學院制定的辦學方向就是:「介紹西洋藝術,整理中國藝術,調和中西藝術,創造時代藝術。」

同樣留學法國的徐悲鴻,則極力主張用寫實主義來改造中國畫。他認爲「素描」是一切造型藝術的基礎,並將這一主張貫徹在教學和自己的藝術實踐中。在技術上,他提出了繪畫的「新七法」:一,位置得宜;二,比例準確;三,黑白分明;四,動作或姿態天然;五,輕重和諧;六,性格畢現;七,傳神阿堵。這些方法都雖然是建立在西方繪畫的透視、解剖、比例、光影等寫實主義基礎造型手法之上的,但徐悲鴻所求的人物花鳥的標準確實是宋人的水準。在這一點上,他和康有爲是相同的。徐悲

鴻對中國文人山水畫畫風也是極其反感，嘲諷「董其昌、王石谷一類淺陋寡聞，從未見過崇山峻嶺，而閉門畫了一輩子的人造自來山水」，「眞是慘不可言，無顏見人（這是實話，因畫中無人物也）並無顏見祖先」！ [4] 正因如此，徐悲鴻一生的繪畫主要涉及人物和走獸，幾乎不涉及山水。

高劍父、林風眠、徐悲鴻、傅抱石等藝術家的呼籲和探索，讓中國的現代藝術在開創之初就具有非凡的氣魄和水平。這些曾經留學東西洋的藝術家，用自己的切身體驗和藝術實踐，對改變當時的中國藝術界對外來藝術的認識起到了重要作用。卽便是極力捍衛傳統的藝術家，也開始接受中西繪畫並存的觀點。作爲二十世紀傳統派的代表之一，潘天壽在 1926 年出版的《中國繪畫史》一書中，就呼籲「無論何種藝術，有其特殊價値者，均可並存於人間」[5] 他雖然一直強調東西方藝術是兩個完全獨立的系統，並認爲保持東方特色是中國畫賴以立足世界的根本所在，但也承認西方藝術是不亞於東方的另一個高峰。

一個不可否認的事實是，中國的現代藝術史既是西方現代藝術在中國的傳播史，同時也是中國傳統藝術對話西方現代藝術的過程。國家與民族的特殊歷史命運，讓現代中國各種藝術探索都蒙上了政治和社會功能的色彩。就如同中國的現代化轉型過程一樣，中國藝術現代性的轉型過程也是跌宕起伏的。藝術問題往往被當成藝術家的信仰和價值觀問題，

由此而產生的各種藝術作品也被人爲地劃派歸類。很多題材和風格上的爭論，在本質上已經變成了對藝術社會功能的爭論。藝術家個人的命運也隨着這種爭論的政治化而不斷變化。可以說，在中國藝術史的長河中，過去的一個世紀充滿了大風大浪。這種激蕩雖然是不安的，有時是痛苦的，但卻催生了大量優秀的藝術，中國藝術的變更之大是史無前例的。

一個多世紀過去了，這個波瀾壯闊的藝術篇章仍然在延續。關於中西與古今、傳統和當代的爭論也一直沒有中斷，有時這種爭論還會變得很激烈。一個値得欣喜的現象是，越來越多的中國當代藝術家已經漸漸擺脫如何對待西方現代藝術的影響和自身藝術獨立性訴求的矛盾，而是更自覺地並獨立地探索具有原創性的藝術。在經歷了 1980 年代中期以來的各種藝術衝擊之後，當代的中國藝術家群體在主題上變得更加理性化，對藝術的創作更具有主動性。傳統仍然是強大的，但中國當代藝術已經不再僅僅停留於對中國傳統的盲目自信。西方仍然具有衝擊力，但中國當代藝術已經超越了對西方的迷信和簡單的模仿。大量堪稱經典的藝術作品的出現，讓當代中國藝術成爲全球藝術中一顆耀眼的明星，並成爲當代西方博物館收藏和展示的重要部分。當代中國藝術已經不僅僅是中國的，更是世界的，是全球人類藝術的一分子。

呈現在讀者面前的這些藝術品，是八位當代中國藝

術家的新探索和新試驗。這八位藝術家分別出生於 1960 年代、
1970 年代和 1980 年代，其年齡在中國當代藝術家群體中很具
有代表性。他們都受過嚴格的中國傳統藝術教育，但他們也洞
悉西方當代藝術。中國文化的熏陶和經歷使得他們的藝術能深
刻地表現中國的歷史傳統和社會現實，但是開放的國際視野和
對西方現代藝術的熟知又讓他們能打破傳統的規範和程式的限
制。這些藝術既是傳統的現代詮釋，也是全新的試驗探索。他
們的作品不僅被國內的藝術機構和藏家所青睞，也曾在世界很
多地方展示，有些還被歐美著名的美術館和博物館收藏。他們
既是當代中國的藝術家，也是當代世界的藝術家。對話傳統、
兼容中西，是這次「藝文香港」的主題，也是對這八位藝術家
作品最好的概括。

1　錢鍾書：〈中國詩與中國畫〉，見《七綴集》，上
海古籍出版社，1985 年。頁 1-2。

2　高劍父：〈我的現代國畫觀〉，見郎紹君、水中天
編：《二十世紀中國美術文選》，上海書畫出版
社，1999 年。頁 518。

3　林風眠：《藝術叢論》，正中書局，1936 年。頁
13-14。

4　徐悲鴻：〈復興中國藝術運動〉（1948 年 4 月 30
日），見《徐悲鴻談藝錄》，河南美術出版社，
2000 年。頁 91。

5　潘天壽：《中國繪畫史》，上海人民出版社，
1983 年。頁 300。

Foreword II

TIANLONG JIAO

When discussing the historical development of Chinese ink painting, renowned 20th century Chinese literary scholar and writer Mr. Qian Zhongshu once postulated a theory regarding the relationship between art and its milieu: "An artist always creates under certain social conditions, against the background of a certain artistic and cultural zeitgeist, which inevitably affects his choice of subject matter, genre, and style. The zeitgeist blesses him with opportunities but also limits him with restrictions. Even the artist who resists or turns away from the zeitgeist is still defined by it in a negative sense, because his motivations stem from the desire to break free from, or rectify, that which he so loathes."[1] In another manner of speaking, the zeitgeist contributes to the manifestation of the artistic style of its era, and in so doing, expresses the very contemporaneity of art. Mercurial and ever-changing, the zeitgeist of a given society is contingent upon a myriad of factors, including historical traditions, social recognition, as well as personal and collective artistic and cultural explorations. For any resultant artistic style to stand up to the test of time, it must be marked by this quality of contemporaneity as defined by its zeitgeist; and as history evolves, such formerly "contemporary" artistic styles become inducted into the halls of tradition. It is the many consecutive disparate contemporaneities of each unique era that constitute the infinite resplendent waves within the long tides of history.

Tradition has always played a powerful role in the history of Chinese art. However, the development of Chinese art is defined not by dutiful allegiance to tradition but by constant innovation. Chinese calligrapher, painter, and scholar Zhao Mengfu, who established the artistic style of the *Yuan* Dynasty, credited the great masters of the *Tang* Dynasty as his source of inspiration and their work as his object of mimesis. He was known to take pride in the fact that his aesthetic conception and horse painting techniques were on a par with painter Han Gan of the *Tang* Dynasty. However, Zhao's art is celebrated not as accomplished replications of *Tang* Dynasty art but as a new style marked by a *Yuan* Dynasty ethos. In particular, Zhao's aesthetic pursuit of the theme of reclusive living in simplistic harmony with nature opened up new possibilities for the genre of landscape painting, which ultimately influenced artists in the *Yuan* Dynasty as well as generations beyond. Meanwhile, in the late *Ming* Dynasty, Chinese painter, calligrapher, and politician Dong Qichang studied the north and south traditions of Chinese painting and diligently practised the brushwork of the ancient masters. But while he advocated the need to emulate the past, Dong's prerogative was to strive for breakthrough and innovation. His own style did not adhere to that of any single predecessor or era; rather, he sought to transform the styles from antiquity in order to forge a new paradigm. For Dong, the ancient classical landscape paintings all represented each artist's internal understanding and experience of nature, transcending external realities. Accordingly, he advocated for a transcendental style of landscape

painting, establishing a new aesthetic approach that went on to influence the *Qing* Dynasty. As evidenced from the historical trajectory of Chinese art, when tradition is employed as a springboard for inspiration and transformation, rather than as a restricting framework prohibiting change, innovation arises to influence generations that follow.

The period following the late *Qing* Dynasty and the May Fourth Movement brought forth dynamic cultural shifts that ultimately unveiled the modern chapter of Chinese art. The influx of Western art caused great rupture; supporters hailed it as the saving grace of Chinese art, doubters proclaimed it as the downfall of Chinese tradition, while most sought for a path forward by integrating the strengths from East and West. Several generations of young Chinese artists ventured abroad to commence studies on Western art history and techniques, hoping to better navigate the future direction for Chinese art.

At the time, there was heated debate over the issue of the revitalization of Chinese art. In lamenting the "drastic decline of Chinese painting in modern times", Kang Youwei, prominent political thinker and reformer of the late *Qing* Dynasty, placed the blame on literati painting that arose from the *Yuan* Dynasty, asserting that the way to revitalize Chinese art was to revert to *Song* realism while referencing Western techniques. In this regard, Kang Youwei, Zhao Mengfu and Dong Qichang were united in their gaze towards tradition. Chinese revolutionary socialist, educator, philosopher

and author Chen Duxiu, however, proposed a complete "artistic revolution." In 1918, his article in the *New Youth* magazine called for a categorical overturning of freehand-centred literati painting, advocating that "to improve Chinese painting, we must adopt the spirit of Western realism" and that "artists must use realism to unleash their talents and forge their own paths, rather than getting stuck in the rut of ancient painters." While there was a consensus between Chen Duxiu and Kang Youwei over the "grave depravity" of literati painting arising from the *Yuan* Dynasty, Chen's views as a leader of the New Culture Movement were radical in their complete forsaking of tradition. Kang and Chen's assertions had a profound impact on China in the early 20th century, inspiring many Chinese artists to look overseas in their quests for a new direction for Chinese art.

That said, many artists who actually pursued studies abroad and witnessed Western techniques first-hand sought to fuse the strengths of Chinese and foreign techniques. Gao Jianfu, who studied in Japan and founded the "Lingnan School", declared: "In regard to painting, we must eclectically and innovatively analyse the strengths of ancient art, modern art, Chinese art and foreign art, so as to reach a synthesis that is balanced and all-embracing." He added, "New Chinese painting comprehensively fuses strengths from diverse styles; is at once realistic and aesthetically oriented; and is simultaneously rational and enticing. It exudes the spirit and charm of Chinese painting while

being backed by the scientific techniques of Western painting."[2] Gao Jianfu adheres to his own teachings in his artistic practice. By combining Chinese brush and ink traditions with Japanese techniques of depicting light, colour and air, he established a new artistic style, i.e. the "Lingnan School", which continues to influence artists today.

Likewise, Fu Baoshi, who studied in Japan from 1933 to 1935, proactively immersed himself in the period's contemporary Japanese techniques. He advocated against complacency in Chinese painting, calling for artists to absorb the strengths of Eastern and Western paintings, digest them, and utilise them as their own tools. Fu's representative style of scattered front brushwork was inspired precisely by Japanese painting. The renowned "Baoshi Textured Strokes" in modern Chinese art led to Fu Baoshi becoming an important pioneer of the "New Jinling School of Fine Arts."

Lin Fengmian (1900-1991), who studied in France, also called for a reconciliation of the common grounds of Chinese and Western art, specifically regarding expression and form. In 1926, in his article in *The Future of Eastern and Western Art*, he stated his opinions on the similarities and differences between Eastern and Western art: "Western art focuses on the imitation of nature; as such, it tends to be realistic. Eastern art is centred around the depiction of the mind; as such, it tends towards the abstract. The motivation behind artistic creation is human emotion, the expression of which requires a form. The former places the form in

the external; the latter in the internal. It is this difference that manifests in the difference in expression and resulting style."[3] He believed Chinese and Western art to be similar in terms of "scientific method and technique", and that the difference lay in the form of expression, i.e. realism versus abstraction. Accordingly, he advocated for a "reconciliation of Chinese and Western art", and forged a unique artistic style via his own practice. In 1928, Lin Fengmian became the Dean of the National Academy of Arts, the first academy of fine arts in China, and promulgated the academy's motto: "Bring in Western art; revitalise Chinese art; reconcile Chinese and Western art; and create the art of our times."

Meanwhile, Xu Beihong, who also studied in France, strongly called for a focus on realism to bring about the revitalisation of Chinese painting. He believed "drawing" to be the basis of all plastic arts and implemented this in his teaching and artistic practice. In terms of technique, he advocated "seven new methods" of painting: 1. Proper position; 2. Accurate proportions; 3. A clear distinction between black and white; 4. Natural movement or posture; 5. Harmony in weights; 6. Complete display of characters; 7. Vivid expression. While these methods are based on the basic techniques of realism in Western art, such as perspective, anatomy, proportion, light and shadow, etc., Xu still followed the artistic standards from the *Song* Dynasty when depicting flowers and birds. Like Kang Youwei, Xu condemned the Chinese literati landscape painting style, stating in ridicule: "Dong

Qichang and Wang Shigu etc. were ignorant. They never saw great mountains and steep ridges in real life, but painted artificial landscapes for their whole lives behind closed doors." He also decried: "It is tragic and pathetic. They should be ashamed to face their peers (I mean this in a literal sense, as there are no figures in their paintings) and their ancestors!"[4] In line with his beliefs, Xu Beihong's own creations throughout his life rarely ventured towards landscape, focusing mainly on figures and animals instead of landscapes.

From the very beginning, the teachings and practical explorations of artists such as Gao Jianfu, Lin Fengmian, Xu Beihong, Fu Baoshi, etc. established extraordinary vigour and high standards for modern Chinese art. Armed with first-hand encounters and experiences from their respective artistic explorations, the artists who pursued studies abroad played an important role in changing the Chinese art scene's understanding of foreign art. Gradually, even artists who had originally ardently defended tradition began to accept the idea of the coexistence of Chinese and Western art. As one of the representatives of the traditional school in the 20th century, Pan Tianshou, in his book *History of Chinese Painting*, published in 1926, declared: "All kinds of art, regardless of type and special characteristics, should be able to coexist in the human world so long as they boast unique values."[5] Although he had all along emphasised that Eastern art and Western art were two completely distinct and independent systems, and that the

preservation of Eastern characteristics was key to the future international standing of Chinese painting, he nevertheless recognised Western art to be as accomplished as Eastern aesthetics.

An undeniable fact is that the history of modern Chinese art is not merely about the process of dissemination of modern Western art within China, but also about the process of dialogue between traditional Chinese art and modern Western art. Because of China's unique history as a nation, various explorations in modern Chinese art are often analysed under a political and social lens. Not unlike the process of China's modernization, the process of transformation of modern Chinese art had its ups and downs. Ideas in art were often classified as ideas exclusive to an artist's personal beliefs or values, such that artworks were artificially classified as secular, while disputes over subject matter and style turned in essence into disputes over the social function of art. As a consequence of such a politicisation of art, an artist's fate also constantly changed. In other words, the past century was a turbulent chapter in the long history of Chinese art. Although this turbulence was unsettling and at times painful, it nevertheless gave fruition to countless great creations, leading to unprecedented transformation in Chinese art.

Over a century later, this magnificent chapter of art history continues. The debates surrounding "Chinese versus Western", "then versus now", "tradition versus modernity" never ended, and have at times become

even more heated. One encouraging observation was how contemporary Chinese artists increasingly overcame the struggle between Western influence and impartial thought to commence conscious, independent and original artistic explorations. After experiencing the various ruptures and shifts since the mid-1980s, contemporary Chinese artist groups became more rational in their chosen subject matters and more proactive in their artistic practice. While tradition is still deep-rooted, contemporary Chinese creation no longer blindly worships tradition; likewise, while Western art was still an important influence, contemporary Chinese art outgrew its initial fascination with the West and ceased all non-critical imitation. An abundance of acclaimed and canonical artworks emerged, many of which were exhibited in or even entered the permanent collections of Western museums and institutions, firmly placing contemporary Chinese art on the global stage. Contemporary Chinese art does not merely belong to China, but to the world; it has become a part of global art history.

The artworks presented in this exhibition are the creative explorations and artistic experiments by eight contemporary Chinese artists. Born respectively in the 1960s, 1970s and 1980s, these eight artists hail from a critical generation in contemporary Chinese art. They all received rigorous training in traditional Chinese art while at the same time possess insights regarding Western contemporary art. Raised under the influence of Chinese culture, these artists are able to profoundly express China's historical traditions and social realities; at the same time, their global horizons and familiarity with modern Western art allows them to break from tradition and surpass formal constraints. The resulting artworks are simultaneously modern interpretations of tradition and utterly novel innovations. Not only are these artists' works admired and coveted by Chinese institutions and collectors, they have been exhibited in numerous global platforms and, furthermore, reside in prestigious institutional collections in Europe and the United States. They are contemporary Chinese artists. They are also contemporary artists of the world. The theme of ART HONG KONG - "Tradition and Modernity" - encapsulates the artistic creations of these eight artists.

1 Qian Zhongshu, "Chinese Poetry and Chinese Painting" , in *Seven Essays on Art and Literature* (Shanghai Classics Publishing House, 1985), pp.1-2.

2 Gao Jianfu, "My View of Modern Chinese Painting" , in *The Selected Works of Fine Arts in 20th Century*, ed. Lang Shaojun & Shui Zhongtian (Shanghai Calligraphy and Painting Publishing House, 1999), p.518.

3 Lin Fengmian, *Mei Shu Chong Lun* [Art Book Series] (Cheng Chung Book Co., Ltd., 1936), pp.13-14.

4 Xu Beihong, "Fuxing Zhongguo Yishu Yundong" [A Movement to Revive Chinese Art] (April 30, 1948), in *Xu Beihong Tan Yi Lu* [Xu Beihong on Art] (Henan Fine Arts Publishing House, 2000), p.91.

5 Pan Tianshou, *Zhongguo Huihua Shi* [History of Chinese Painting] (Shanghai People's Publishing House, 1983), p.300.

傳統在中國藝術發展歷程中的作用力是強大的，而創新更是中國藝術生命力的根本。對話傳統而又不斷地變革，立足本土而又能博採他人之藝，使不同時期的中國藝術都具有強烈的時代特徵。這些不同時期藝術的當代性特色，就構成了中國藝術史長河中引人注目的浪花。

本次展覽既是當代藝術與傳統文化的對話，也是中國傳統與西方藝術的互鑒。六位中國現代藝術大師及八位當代藝術家的作品，從不同的角度解讀「傳統」與「前衛」的辯證聯繫，通過多元的表現手法詮釋古代藝術與當今社會的關聯，在當代的藝術風格中折射歷久彌新的經典。

古今對話 —— 本展覽以當代藝術創作為主，從當代視角發掘經典的魅力。借助多元的藝術形式充分展示傳統藝術的當代性，詮釋古代藝術與當代社會的關聯性，並與當代觀眾建立新的連結和互動。同時，通過藝術家的最新創作，呈現當代藝術對傳統的繼承和時空上的連續性，探索傳統文化對當代藝術家的啟發，透過當代的視角體驗傳統藝術與文化典範。

中西互鑒 —— 探討西方藝術對中國當代藝術的影響，以及中國當代藝術在世界藝術發展歷程當中發揮的作用；促進海內外藝術家在共同國際視野下對於藝術發展的溝通和對話，並思考及探索中國當代藝術的未來發展方向。

The historical development of Chinese art is anchored to the inimitable force of tradition. Its vitality, however, is hinged upon innovation. Over the course of history, artists have engaged in dialogues with tradition while insisting on constant innovation, and upheld Chinese cultures while seeking inspiration from foreign artistic accomplishments. This has led to singular achievements in each distinct period in Chinese art. It is the many exceptional characteristics of each unique era that constitute the shimmering resplendent waves in the long tides in Chinese art history.

This exhibition is a dialogue between contemporary art and traditional culture and a conversation between Chinese tradition and Western art. The works by six modern Chinese ink masters and eight contemporary Chinese artists utilise different perspectives in their interpretation of the dialectical relationship between "tradition" and the "avant-garde". By employing varied forms of expression to interpret the connection between ancient art and contemporary society, the works shine new light on timeless classics in diverse contemporary styles.

Tradition – explore the beauty, contemporaneity and diversity of traditional Chinese art from the contemporary art practice's perspective; interpret the correlation between traditional art and the modern times, establishing connection and interaction with the audiences of the contemporary world; demonstrate contemporary art's inheritance and continuity of its predecessors through the latest works by contemporary Chinese artists; discover how contemporary artists are inspired by traditional culture.

Modernity – discuss the influence of Western art on contemporary Chinese art, and the role of contemporary Chinese art in the global art development; encourage communications and dialogues on art development amongst local and overseas artists sharing a common global vision; explore the future of contemporary Chinese art.

知名當代藝術家
RENOWNED
CONTEMPORARY ARTISTS

王天德
WANG TIANDE

1960 / 上海 / SHANGHAI

王天德，畢業於浙江美術學院（後更名中國美術學院）。現生活、工作於上海，擔任上海復旦大學教授。

王天德是中國前衛水墨畫的開創者之一，他獨創的燒燻水墨畫，用香燙的形式將山水與宣紙層層疊加，開創了極具感染力的新水墨風格。藝術家以新的創造性語言詮釋水墨藝術，將山水圖式與古代碑拓、墨跡相並置，構成觀念化的當代水墨語言，與此同時也反映中國傳統的審美特徵。

Wang Tiande graduated from the Zhejiang Academy of Fine Arts (later renamed the China Academy of Art). As a Professor at Fudan University, he currently lives and works in Shanghai.

Wang is one of the pioneers of avant-garde Chinese contemporary ink art. Through his ground-breaking technique that uses burning incense sticks and ink to paint traditional landscape on layered Xuan paper, the artist creates an impressive modern style for ink-wash painting. His new pictorial language re-conceives traditional Chinese ink by the juxtaposition between landscape forms and ancient ink rubbings, and generates a conceptual mode of contemporary Chinese ink. The integration of different elements reflects the aesthetic sensibility of Chinese artistic traditions as well.

近年參與國際展覽（部分）

2021 「水墨之夢」（Fondation INK 所藏藝術精選），洛杉磯郡藝術博物館
2019 中國展廳，紐約布魯克林博物館
2013 「水墨藝術在當代中國」，紐約大都會博物館
2012 「現代中國畫展」，大英博物館
2008 「變易的水墨」，德累斯頓國家美術館

SELECTED EXHIBITIONS

2021 *Ink Dreams* (selections from the Fondation INK Collection), Los Angeles County Museum of Art, USA
2019 The Arts of China Gallery, Brooklyn Museum, New York, USA
2013 *Ink Art: Past as Present in Contemporary China*, Metropolitan Museum of Art, New York, USA
2012 *Chinese Modern Art Exhibition*, British Museum, UK
2008 *The Transforming Marks of Ink*, Staatliche Kunstsammlungen, Dresden, Germany

《廬茨三水圖》

2021 年初，追隨項聖謨的《三招隱圖》重遊富春江。

當日逆水而上，夜宿蘆茨樹，遇狂風暴雨。次日雲開天晴，一家人泛舟江面，水面寬闊平靜，山石平緩起伏。至村口橋孔時，一股暗流撞擊小舟，瞬間翻入江中，水深七至九米，三人浸水掛岩石叢樹間，至今心有餘悸。2022 年春上海因疫情封控，於是在家中創作九聯山水圖作爲印記。

《望坡融雪圖》

畫中有隱寺在山，若隱若現。層巒的山脈，意喻群峰中高的不是山，而是無處尋蹤的人。

作品配以隋代碑刻《龍藏寺碑》的清代拓片，與山水內容彼此呼應。

《望廬浸水圖》

《望廬浸水圖》是以清代石碑《千字文》爲模板，結合 3D 打印技術製作而成的碑文，形成跨越歷史與科技碎片的鏈接。

《屋漏痕》

作品《屋漏痕》由黃賓虹的題跋感悟所創作；「屋漏痕」三字亦是對中國書畫境界的詮釋。此作水痕跡滲入牆體，乾後牆面復歸平整，是以埋牆作品以記之。

Artwork

Three Trips to the Water in the Village of Lutz

In early 2021, Wang revisited the Fuchun River in the hope of seeing the inspiration behind *Ming* Dynasty painter Xiang Shengmo's (1597–1658) *San Zhaoyin Tu* (Beckoning of Solitude).

We travelled up the stream and stayed the night at the village of Lutz in the midst of a violent storm. The sun came out the next day, so the entire family toured around the site on a little boat. The waters were tranquil and rocky crags lined the banks. When we were passing under the bridge, however, a sudden undercurrent hit our boat and we capsized. The depth of the river was between seven to nine metres. The three of us clung to rocks and trees, our lower bodies still submerged in the water—until now, we are still traumatised. Shanghai went under lockdown during the spring of 2022 due to the pandemic. During that period, I created a landscape polyptych of nine panels at home in remembrance of that experience.

Melting Snow on a Slope

In *Melting Snow on a Slope*, a temple hovers in and out of vision. The highest "peak" among the sprawling mountain range, it seems, is not a landform but the recluses and sages who are nowhere to be found.

A rubbing of the Longzang Temple tablet (*Sui* inscription, *Qing* Dynasty rubbing) echoes the theme in the landscape work.

View of Mount Lu in Water

Using the *Qing* stone tablet, *The Thousand Character Classic* as template and produced with 3D printing technology, *View of Mount Lu in Water* is a textual work straddling the historical and the cutting-edge.

Wu Lou Hen (Leaked Traces from a House)

Wang's work *Wu Lou Hen (Leaked Traces from a House)* was inspired by an inscription by modern Chinese painter Huang Binhong. The three Chinese characters of the title, "wu lou hen", are also a meditation on the essence of Chinese painting and calligraphy. First, bits of water left marks on the wall; once dried, the wall is restored to its original appearance. A record, in the fleeting form of water, was made in the wall, though no longer visible.

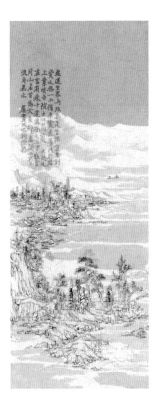
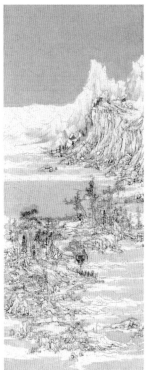
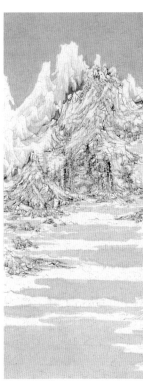
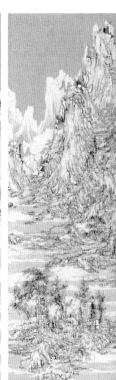

盧茨三水圖

宣紙、墨、火焰、書帖（清代）
李宗瀚行書韋應物詩 187 x 46 厘米
九聯作 185 x 73.5 厘米 x 9

**Three Trips to the Water
in the Village of Lutz**

2021-2022

Ink on paper, burn marks, calligraphy of *Qing* Dynasty
Li Zonghan Calligraphy, Wei Yingwu's poems 187 x 46 cm
Set of nine panels, framed 185 x 73.5 cm x 9

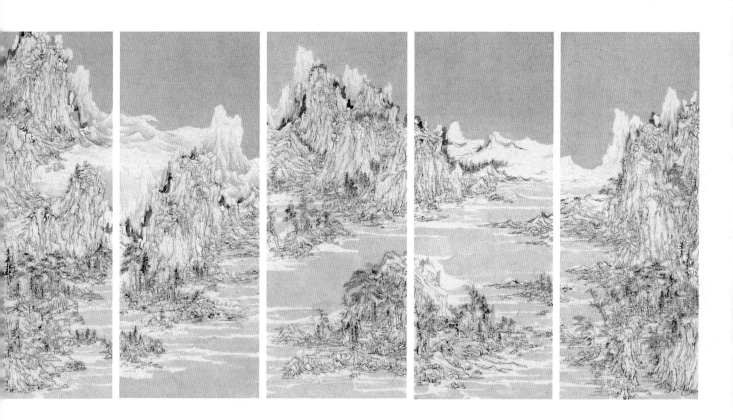

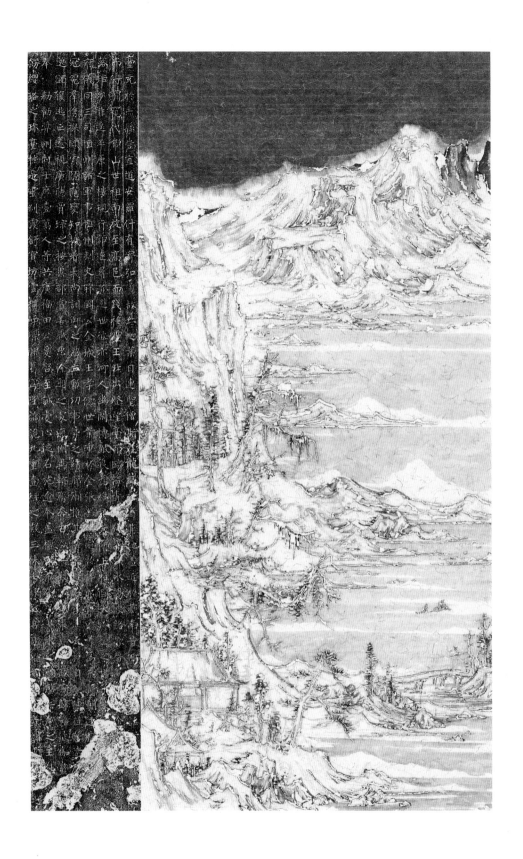

望坡融雪圖

宣紙、墨、火焰、石碑拓印（清代）
153 x 96.5 厘米

Melting Snow on a Slope　　　　　　　　　2020

Ink on paper, burn marks, stele rubbing of *Qing* Dynasty
153 x 96.5 cm

望廬浸水圖

宣紙、墨、火焰、木、三維打印、石碑拓印（清代）
30.2 x 114.6 厘米 x 2

View of Mount Lu in Water

2021

Ink on paper, burn marks, wood, 3D printing, stele rubbing of *Qing* Dynasty
30.2 x 114.6 cm x 2

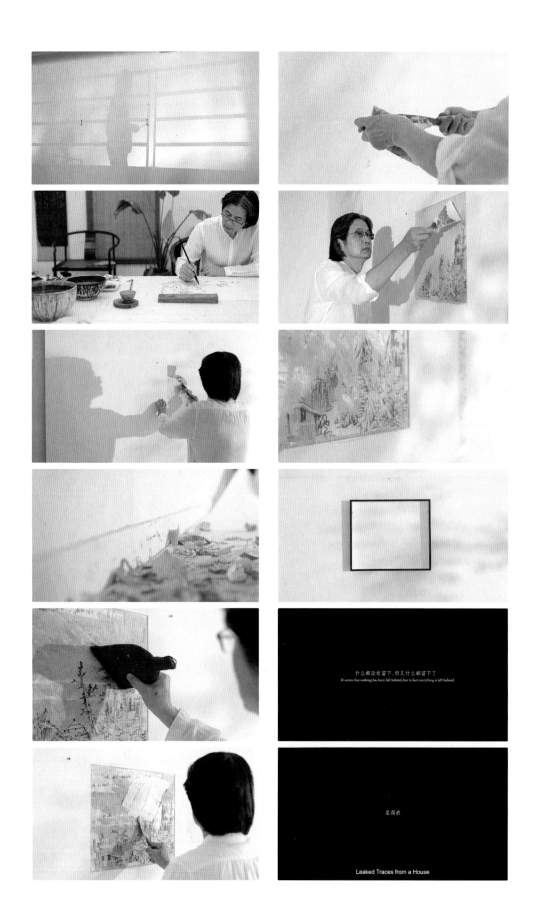

屋漏痕

宣紙、墨、火焰、石膏牆、錄像
畫芯 53 x 42 厘米
畫框 76 x 65 厘米

Wu Lou Hen (Leaked Traces from a House) 2022

Ink on paper, burn marks, plaster wall, video
Painting core 53 x 42 cm
Frame 76 x 65 cm

古人作書有屋漏痕法何紹基學顏魯公清道人又學何紹基秀發何善近睹斯軸蓋為精進由此上溯商周不難也　黃賓虹題　樂唐兄英年俊慧暇習書法前數載中所作之覽

黃賓虹（1865-1955）
行書題跋
水墨紙本
52.5 x 9 厘米

Huang Binhong (1865-1955)
Inscription in Running Script
Ink on paper
52.5 x 9 cm

林天行
LAM TIANXING

1963 / 福州 / FUZHOU

林天行，生於中國福州。1984 年移居香港，1989 年就讀北京中央美術學院。他將傳統中國田園山水情懷，注入現代都市水墨，從而建構現代重彩超現實意味的新美學觀。

Lam Tianxing was born in Fuzhou, China. He moved to Hong Kong in 1984 and studied at the Central Academy of Fine Arts in Beijing in 1989. Lam injected contemporary ink techniques into the traditional Chinese pastoral landscapes, creating intricately detailed pieces of colour-filled, imaginative art which depicts urban landscape.

近年參與國際展覽（部分）

個展
2012　韓國首爾 K 畫廊
2011　意大利米蘭布朗尼藝術空間
聯展
2022　「全國優秀美術作品展覽」，上海
2002　「香港風情・水墨變奏」，倫敦大學
2001　「百年中國畫展」，北京中國美術館

SELECTED EXHIBITIONS

SOLO EXHIBITIONS
2012　The K Gallery, Seoul, Korea
2011　Fabbica Borroni, Milan, Italy
GROUP EXHIBITIONS
2022　*National Exhibtion of Outstanding Works of Fine Arts*, Shanghai, China
2002　*Hong Kong Cityscapes: Ink Painting in Transition*, University of London, London, UK
2001　*20th Century Traditional Chinese Painting Exhibition*, National Art Museum of China, Beijing, China

「景象」種種

打開窗口一陣涼風撲面而來；混合着各種機器的喧囂聲，夾雜着積濁油污的氣味，到處閃亮的燈光令深秋的夜晚失去它原有的神秘，散落在街道的電燈杆在高聳如懸崖的石屎森林下顯得格外孤獨、冷清和無奈。大自然的芬芳在這裏成了美好的回憶！有幸的，窗外還能望見幾棵風雨中飄搖的樹影，仍然伸開那頑強的枝幹，時刻呈現出自然的風采、煥發着勃勃生機的景象，撫慰被庸俗事物騷擾的都市人的心靈。

生活在沒有高山流水，長林巨壑的環境中，缺乏煙雲滋養、山林熏染的熙攘都市，如何領略「仰視壑木杪，俯聆大壑淙」之妙。面對令人目眩的科技、資訊爆炸的非凡時代，緊張快速的生活節奏，在無以喘息的時空，許多人都成了追求時尚的機器、物欲的奴隸、毀滅大自然的工具，在扭曲了的心態下，各自享受現代文明所帶來豐富資源的同時，也在承受着痛苦和矛盾。傳統的「靈丹妙藥」正面臨失效的危機。

置身於大時代縫隙求存的藝術家，又該如何把握住自身的藝術生命，並走出狹窄，重塑一個屬於今天的「真理」；抑或隨波逐流繼續掠奪和炫耀前人的成就而沾沾自喜。

難以理解，「世外桃源」式不食人間煙火的超然之境，悠然、自在、坐忘、閑適早已成為逝去的白日夢的今天，如何體味清涼、淡泊。以重複又重複的凝固情感製造一張又一張蒼白無力的「空殼」的莫名心態，怎能以傳統精神與現代文化環境來表現；在遵循「搜盡奇峰打草稿」是否為走向生活、反映時代的惟一良方，當回顧其特定時空的意義，作為永遠的範本，石濤「筆墨當隨時代」又是在怎樣的歷史環境下高聲疾呼的。

在這多元文化的時代，任何事物都已失去它原有的意義與純度，一切盡在混合中成長，固守「山水文化」載體，以傳統規範的準則，來作為統殺不夠「傳統」的武器，無疑對傳統誤解而導向淪落成「文物」的險境。

誠然，水墨畫要表現今天人們現實生存的境遇，光靠前人留下的那點遺產是難以勝任的，作為有意改革的勇士們，不得不鋌而走險去尋覓未曾被發現或隨處充斥不可知的神秘現象與力量，藉以喚醒長眠心中的直覺以及藝術情懷，拋掉所有概念，將感覺的魅惑與象徵的效果形象化，以趨達到「精神的真實」。

如果能用心留意周圍的一切，你會發現所有現象都具有其懾人的魅力，身邊鮮活的景象以及時代的產物自有其獨具的「情趣」，新「意境」就在你眼前，就在你心中。那陽光下的公園，棕櫚樹旁，等待着生活奔波勞累的人們休息的長椅，那用木條連接而成的小亭，不也成了人們暫阻風雨的「避風港」嗎？還有那我兒時一直嚮往的鞦韆、一排排彎曲的鐵欄、一根根孤寂的燈柱、被朦朧月色籠罩着的屋村、風雨中匆匆掠過的巴士、停在矮矮山巒上的私家車、白雲從車輪下徐徐飄過的美妙，以及那橫臥在比山還高的座座大廈上面的蔚藍色的大海、來自五湖四海色彩繽紛的船隻，給這冷冷的都市增添了暖暖的異彩，令人羨慕自由自在的魚兒追逐着映照在大海上的霓虹燈⋯⋯這些都是我生活周圍多姿多彩的點滴，也是我平常關注的「景象」，我願意體驗和挖掘這平凡角落的真實，它們都成了我的畫縱橫交錯的「點、線、面」韻律，交織成勃勃生機的「元素」來建構一種超越自然與時空的理想「時境」的「心界」，從而表現屬於今天的種種「景象」。

Artwork

All About "Sceneries"

When I opened the window, the breeze came in mixing with roaring noises from all kinds of engines whilst wafted with greasy smell. Lights - emanating from homes or from the streets have stripped away mystery of the late autumn nights. The lamp posts dotting the roads appeared lonely in the midst of "concrete jungle." The fragrance of nature has become fond memories. Luckily when peering through the window, there are still trees out there fighting against harsh conditions to survive, their branches swinging and struggling against the pouring rain and the unforgiving wind. This compelling display of nature's resilience and the energetic pulse of life have offered comforts to the hearts of mankind and alleviated all their worries.

Living in a bustling city such as ours, one that lacks the nourishment of towering mountains, waterfalls, misty clouds, and rich forests, how will we be able to "experience the majestic woods and listen to the dancing rhythms of the river beneath"? In this modern age of advanced technology and information explosions, dizzying life of constant upgrades and hyper-consumptions, many have become blind followers of trends, slaves of consuming desires and culprits of ruining the nature. In the end, human is facing a dilemma that whilst enjoying the rich resources brought about by the improvements in lives, we are also suffering from what we have not preserved. The "meditation offered from nature" is losing its effectiveness.

Artists are faced with the daunting challenge of surviving from the limited space within this contemporary epoch. How can we escape from the world's temptations and restore the "lost truths"? Or, should we just go with the flow and succumb to hollow praises?

I have always found it difficult to understand: how will one ever be able to experience a simple way of living if the utopian way of life has already become a distant dream? Would it be meaningful for a repetition of traditional paintings? If so, then how could a great master such as the early *Qing* painter Shi Tao (1642 – 1707) manage to lead a contemporary way of painting against those historical background.

In this era of multiculturalism where the east meets with west, it seems that we have grown to accept a mixture of different culture. In such case, conservatism may become an obstacle for the development of contemporary art. Today's Chinese paintings may have to follow the pace of the ever-changing world.

In fact, to portray our lives today using contemporary water ink, relying only on the inherited repository of tools and methodology of classical painting techniques are inadequate. For those who are courageous enough to revolutionise, they must take risks to explore uncharted waters and uncover mysterious phenomenons and powers. This helps awake artists' instincts and their artistic spirits, forget about the irrelevance so as to depict tempting ideas and feelings. It is exactly how "spirit in a concrete reality" works.

If one can pay more attention to the daily surroundings, it is not difficult to discover charming scenes. In a sunny garden, next to the palm tree, there is a long chair for tired people to rest on. The little wooden pavilion is a promised shelter on rainy days, isn't it? I can also see my beloved swings, rows of railings, lots of lonely lamp posts, cottages under the moonlight, buses rushing through the heavy squalls, a car parking by the side of a little hill, the bright blue sea lingering above the tall buildings in the distance, and brilliantly-hued ships from all over the world. They are dressing the cold city with warmth and colours. Fishes prancing in the sea, chasing the reflections of neon lights are what we should envy. ... These are all lovely fragments of life that I always cherish. I am keen to search and uncover these interesting and inspiring stories hidden in the neglected corners. These life stories have become my "dot, line, space" creations, interweaving with the dynamic natural elements, transcending from space and time to make ideal "scenarios" of today's stories.

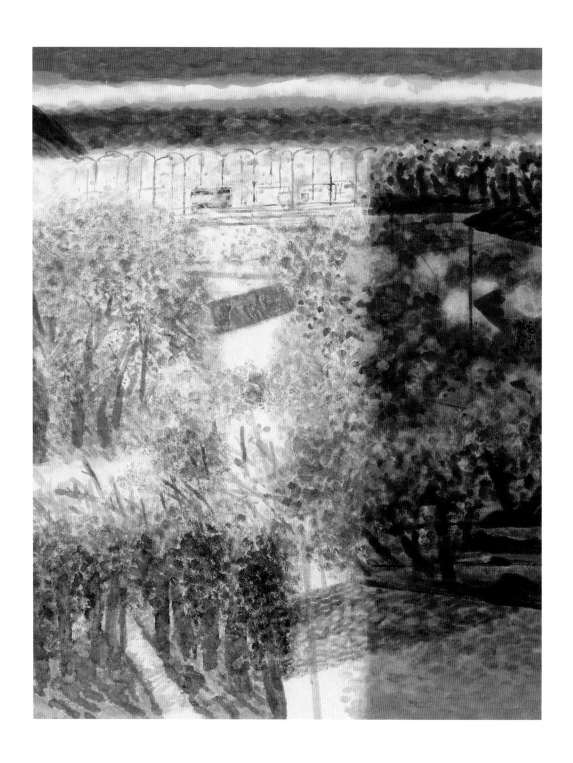

新界日出

水墨設色紙本
184 x 144 厘米
特別鳴謝：林天行工作室

New Territories Sunrise

2022

Ink and colour on paper
184 x 144 cm
Courtesy of Lam Tian Xing Studio

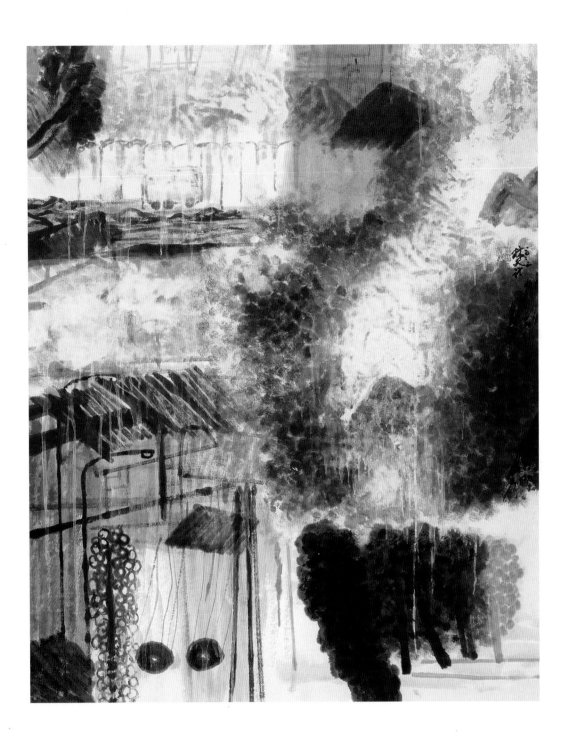

煙雨時光

水墨設色紙本
184 x 144 厘米
特別鳴謝：林天行工作室

Misty Raining Time

Ink and colour on paper
184 x 144 cm
Courtesy of Lam Tian Xing Studio

2022

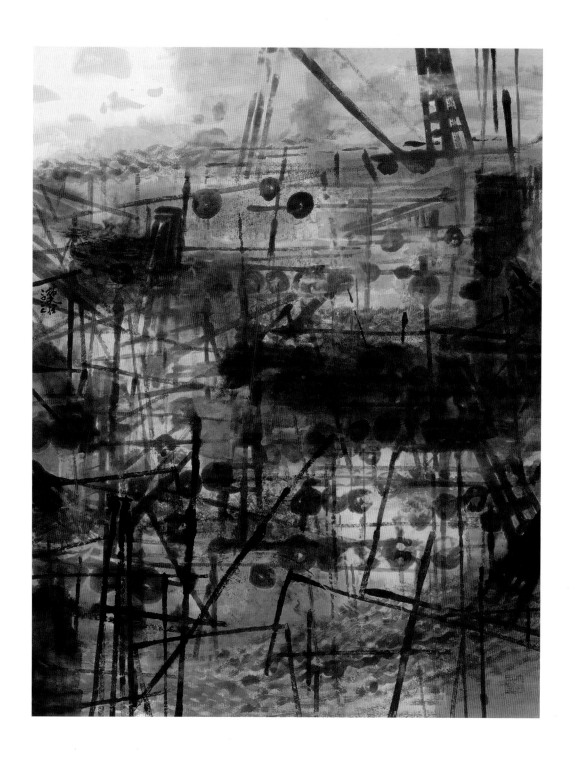

海的故事

水墨設色紙本
184 x 144 厘米
特別鳴謝：林天行工作室

The Story of the Sea

Ink and colour on paper
184 x 144 cm
Courtesy of Lam Tian Xing Studio

2022

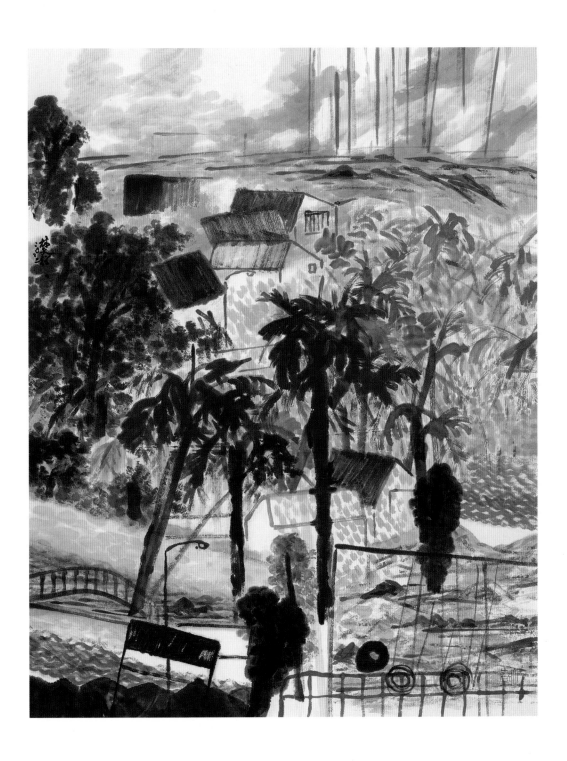

山上山下

水墨設色紙本
184 x 144 厘米
特別鳴謝：林天行工作室

Up and Down the Mountain

2022

Ink and colour on paper
184 x 144 cm
Courtesy of Lam Tian Xing Studio

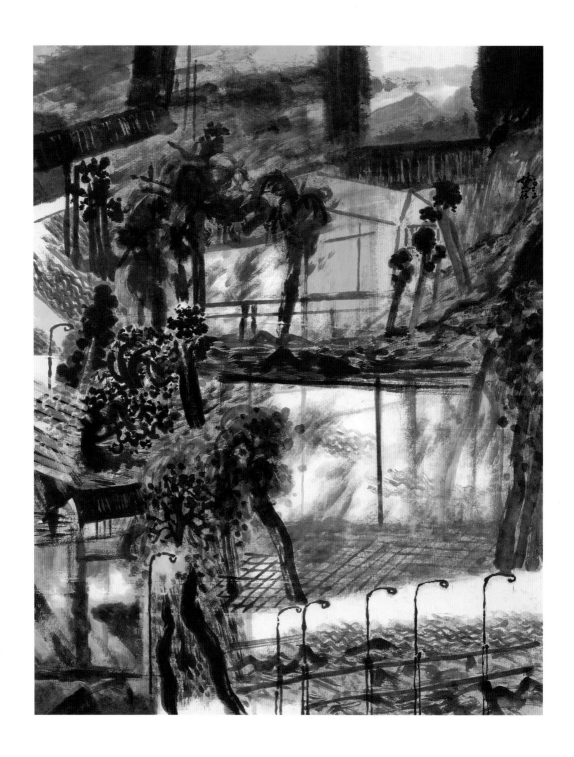

窗前窗後

水墨設色紙本
184 x 144 厘米
特別鳴謝：林天行工作室

In Front of and Behind the Window

2022

Ink and colour on paper
184 x 144 cm
Courtesy of Lam Tian Xing Studio

郝量
HAO LIANG

1983 / 成都 / CHENGDU

郝量 1983 年生於四川成都，畢業於四川美術學院中國畫系，現工作、生活於北京。

郝量將自身感知力的錘煉和中國水墨畫的實踐緊密結合在一起，既深入到中國水墨的歷史考掘水墨本體的奧妙，也從當代生存中體味玄幻敘事的重構。對於郝量，中國水墨畫不僅是關於繪畫技藝與生命過程的相互豐富，更是人對自身和世界關係不斷追問和相互反映的過程。郝量以水墨為載體穿梭、反思於過去與未來之間，感知和探測人類自身在歷史和宇宙中的位置。

Born in Chengdu, Sichuan province in 1983, Hao Liang studied at the Sichuan Fine Arts Institute, Chongqing and received his MFA in Chinese Painting in 2009. He lives and works in Beijing.

Hao fuses tightly the exercise of his own perception and the practice in Chinese ink painting, not only does he dig into the investigations of the ontology of Chinese ink painting within its history, but also experience the reconstruction of surreal narratives from the survival of the present time. For Hao, Chinese ink painting goes beyond the relationship between artistic technique and life experience; it is an individual's reflection on his relationship with the world. Using ink paintings as a time machine, Hao reflects on the past and meditates on the future, exploring endless ruminations and re-imaginations over the position of human beings in history and the universe.

近年參與國際展覽（部分）

個展
2020 「郝量：秋思」，廣州鏡花園
2019 「郝量：辟雍」，上海震旦博物館
2016 「郝量：靈光」，馬斯特里赫特邦納方騰博物館
「郝量：瀟湘八景」，北京尤倫斯當代藝術中心

SELECTED EXHIBITIONS

SOLO EXHIBITIONS
2020 *Hao Liang: Autumn Thoughts*, Mirrored Gardens, Guangzhou, China
2019 *Hao Liang: Circular Pond*, Aurora Museum, Shanghai, China
2016 *Hao Liang: Aura, BACA Projects 2016*, Bonnefantenmuseum, Maastricht, The Netherlands
Hao Liang: Eight Views of Xiaoxiang, Ullens Center for Contemporary Art, Beijing, China

《套數・秋思 — 牛羊野》

《套數・秋思》一題受元曲四大家之一馬致遠的同名套數作品《套數・秋思》（又名《夜行船・秋思》）啟發，「套數」一語暗示了這個系列作品之間既首尾相接、「一韻到底」又各自獨立、形態不一的散曲式抒懷結構；又反映出藝術家對元代繪畫以及現代以來造型變化的揣摩和反思，追問今時的情感形態如何可以通過此種凝練的形式得以凝聚和再造。

《套數・秋思 —— 牛羊野》中的「牛羊野」呼應了《套數・秋思》第二曲〈喬木查〉中的感歎：

想秦宮漢闕，都做了衰草牛羊野。
不恁麼漁樵沒話說。
縱荒墳橫斷碑，不辨龍蛇。

經歷了夢境、預視、理想、現實的境遇，《套數・秋思 —— 牛羊野》中的場景進入到一種深沉的洪荒感，一切似乎復歸平靜，回到太初之勢。那是歷史的廢墟嗎？這又像是從外太空所瞥到的人類生存空間的未來。層層翻卷的雲層和起伏的地形變化結合了元代繪畫和現代造型相撞擊的複雜經驗，在這平靜中所蘊含的對人類終極命運的思慮，彷彿讓我們從現在所處的時刻，共情着百年前的馬致遠，也回應着同樣處於深刻時空變局中的趙孟頫、吳鎮、倪瓚……他們曾以各自的靈視投向未來深深的一瞥，而我們現正置身其中。

《嘒彼小星》

小星

嘒彼小星，三五在東。肅肅宵征，夙夜在公。寔命不同。
嘒彼小星，維參與昴。肅肅宵征，抱衾與裯。寔命不猶。

—— 選自《詩經》，〈國風・召南〉。

《神曲之一》

就在我們人生旅程的中途，
我在一座昏暗的森林之中醒悟過來，
因為我在裏面迷失了正確的道路。
唉！要說出那是一片如何荒涼、如何崎嶇，
如何原始的森林地是多難的一件事呀，
我一想起它心中又會驚懼！
那是多麼辛酸，死也不過如此；
可是為了要探討我在那裏發現的善，
我就得敘一敘我看見的其他事情。

—— 以上節錄自《神曲》「地獄篇：第一歌」，此為全書序曲，描述但丁迷途在一個黑暗的森林，遇見豹、獅、母狼三獸，詩人維吉爾的靈魂來救護他。譯文選自朱維琪譯本，上海譯文出版社，1984 年第一版。

白晝正漸漸消逝，昏暗的影子，
解除了大地上面一切生物
辛勞的感覺；只有我一個人，獨自

準備着應付雙重戰鬥的任務 ——
道途既遙遠，心中又惶懼不安 ——
這一番經過，我將要忠實地敘述：

啊，詩神，崇高的靈感，給我以支援！
啊，記憶，你曾寫下我親身的聞見，
如今該輪到你顯示你的尊嚴。

—— 以上節錄自《神曲》「地獄篇：第二歌」，其中詩人維吉爾敘述但丁暗戀的情人俾德麗采的請求，譯文節選自吳興華殘稿。

Artwork

Suite: Autumn Thoughts – Pasture

The title of this series is inspired by the poem *Taoshu (Suite): Autumn Thoughts* (also known as *Night Boat: Autumn Thoughts*) by Ma Zhiyuan, one of the four great Yuan playwrights. The phrase *Taoshu (Suite)* implies how the works in the series resonate with one another, reverberating in united harmony while each maintaining their own tune, with distinct independent verses coming together in a single coherent structure. The title also refers to the artist's reflections on *Yuan* Dynasty art and the ensuing transformations in form and technique, as well as his explorations on how contemporary feelings and emotions can be condensed and reconstructed through investigations into the past.

The "pasture" in *Suite: Autumn Thoughts – Pasture* responds to a line in the second aria in *Taoshu (Suite): Autumn Thoughts*, i.e. *Qiaomucha* 喬木查 :

I think of ancient palaces, alas!

They become pastures covered with withered grass.

The fishermen's gossip they are aliments,

Crisscrossed with ruined tombs and broken monuments,

On which dragons and snakes are blended.

After passing through the realms of dreams, premonitions, idealistic projections, and physical reality, the scenes in *Suite: Autumn Thoughts – Pasture* enter a state of somber pre-historicity—one that is silent, peaceful, echoing the very beginning of time. Have we arrived at the ruins of history? One also seems to glimpse the future of humanity as seen from outer space. The rolling layers of clouds and shifting undulating lands unite *Yuan* Dynasty techniques with contemporary forms, culminating into a rich and complex visual language. In the midst of the deep stillness, one senses the artist's profound concerns over the fate of human existence, prompting the same contemplations as Ma Zhiyuan from hundreds of years ago. In the same manner, we find ourselves co-existing in the same shifting time-space continuum with artists and scholars such as Zhao Mengfu, Wu Zhen and

Ni Zan, who also lived through turbulent and rapidly changing times. In their respective and unique ways, they have all, in their times, attempted to peer into the murky depths of the future—the very future that we presently reside in.

The quotations of the *Taoshu (Suite): Autumn Thoughts* by Ma Zhiyuan are translated by Xu Yuanchong.

The Starlets Shed Weak Light

<u>The Starlets</u>

Three or five stars shine bright

Over the eastern gate.

We make haste day and night,

Busy early and late.

Different is our fate.

The starlets shed weak light

With the Pleiades o'erheard.

We make haste day and night,

Carrying sheets of bed:

No other way instead.

— "Songs Collected South of Shao, Modern Henan" in "Book of Songs", Book of Poetry, translated by Xu Yuanchong.

Divine Comedy I

In the midway of this our mortal life,

I found me in a gloomy wood, astray

Gone from the path direct: and e'en to tell,

It were no easy task, how savage wild

That forest, how robust and rough its growth,

Which to remember only, my dismay

Renews, in bitterness not far from death.

Yet, to discourse of what there good befell,

All else will I relate discovered there. [1]

—Excerpted from Canto 1 of "Inferno" in *The Divine Comedy* by Dante Alighieri. As the preface to the book, this presents how Dante gets lost in a dark forest and encounters three beasts: the leopard, the lion, and the

she-wolf, and how Virgil's soul comes to rescue him.

Now was the day departing, and the air,

Imbrown'd with shadows, from their toils released

All animals on earth; and I alone

Prepared myself the conflict to sustain,

Both of sad pity, and that perilous road,

Which my unerring memory shall retrace.

O Muses, O high genius, now vouchsafe

Your aid. O mind, that all I saw hast kept

Safe in a written record, here thy worth

And eminent endowments come to proof. [2]

—Excerpted from Canto 2 of "Inferno" in *The Divine Comedy*, where Virgil recounts the request of Beatrice Portinari, whom Dante loves unrequitedly.

1 Dante Alighieri, edited by Tom Grittith, translated by H.F.Cary (Wordsworth Editions, 2012).

2 Dante Alighieri, edited by Tom Grittith, translated by H.F.Cary (Wordsworth Editions, 2012).

套數·秋思 —— 牛羊野

重彩絹本
152 x 216.6 厘米
圖片鳴謝：藝術家及維他命藝術空間
私人收藏，香港

Suite: Autumn Thoughts—Pasture

2018-2019

Ink and colour on silk
152 x 216.6 cm
Photo courtesy of the artist and Vitamin Creative Space
Private collection, Hong Kong

嗶彼小星

重彩絹本
145.5 x 213.5 厘米
圖片鳴謝：藝術家及維他命藝術空間

The Starlets Shed Weak Light　　2022

Ink and colour on silk
145.5 x 213.5 cm
Photo courtesy of the artist and Vitamin Creative Space

神曲之一

重彩絹本
145.5 x 231.5 厘米
圖片鳴謝：藝術家及維他命藝術空間
私人收藏

Divine Comedy I

2021-2022

Ink and colour on silk
145.5 x 231.5 cm
Photo courtesy of the artist and Vitamin Creative Space
Private collection

張恩利
ZHANG ENLI

1965 / 吉林 / JILIN

張恩利，1965 年生於吉林。1989 年畢業於無錫輕工業大學藝術學院，現生活工作在上海。

張恩利的作品主題一直專注於描繪尋常事物以及日常生命活動痕跡。他常將勾畫出的無以名狀的線條與抽象掩映的色塊相互轉化，使畫面獲得了具體的質感與體量感。他的繪畫裝置作品通過融合環境、歷史與個體經驗的體悟，創造性地將觀者置於時間與空間敘事的雙重虛空之中。張恩利通過對於常在事物的不同角度的描繪，引發觀者對「存在」這個命題的不斷思考。

Zhang Enli, born in Jilin province in China in 1965, graduated from the Arts & Design Institute of Wuxi Technical University in 1989 and currently lives and works in Shanghai.

His works focus on the depiction of ordinary objects, spaces, and traces of everyday life. By intertwining relaxed and fluid lines with loose washes of muted tones, Zhang achieves a specific atmosphere that hovers at a liminal reality, distilling mundane objects and environments to their essence. In his series of painting installations known as the "Space Paintings", Zhang creates immersive spaces that unite environment, history, and personal experience, suspending audiences within a void of time and space. Through his portrayals of the prosaic facets of contemporary life, Zhang prompts continuous reflections on the question of existence.

近年參與國際展覽（部分）

個展

2021 「有顏色的房子」，重慶龍美術館
2020 「張恩利：會動的房間」，上海當代藝術博物館
2019 「鳥籠，臨時的房子：張恩利於博爾蓋塞美術館」，羅馬博爾蓋塞美術館
「張恩利｜Oscar Murillo 雙個展」，上海 K11 Art Foundation
2018 「恩利工作室 - 藝術家駐留計劃」，倫敦皇家藝術研究院伯林頓府人體素描室

SELECTED EXHIBITIONS

SOLO EXHIBITIONS

2021 *Zhang Enli: A Room with Colour*, The Long Museum Chongqing, Chongqing, China
2020 *A Room That Can Move*, Power Station of Art, Shanghai, China
2019 *Zhang Enli. Bird Cage*, Galleria Borghese, Rome, Italy
Oscar Murillo. Zhang Enli, K11 Foundation, Shanghai, China
2018 *Zhang Enli: Artist in Residence*, RA Schools, Burlington House, Royal Academy of Arts, London, UK

關於作品

「水」和「樹」是我向中國古人致敬的兩個系列作品，古人畫「樹」其實是畫人，「水」是高遠和內心的波動，這與世界其他地方的藝術完全不同。

Artwork

Water and *Tree* series both pay tribute to Chinese literary ancestors. The ancients painted trees to represent human beings, while water elicits visionary and the fluctuation of the mind, both of which set Chinese art apart from arts from the rest of the world.

樹

油畫畫布
250 x 200 厘米
特別鳴謝：張恩利工作室及香格納畫廊
亞洲私人藏家

Tree 2005

Oil on canvas
250 x 200 cm
Courtesy of Zhang Enli Studio and ShangART Gallery
Asian private collector

老樹（七）

油畫畫布
300 x 250 厘米
特別鳴謝：張恩利工作室及香格納畫廊
亞洲私人藏家

Old Tree (7)　　2014

Oil on canvas
300 x 250 cm
Courtesy of Zhang Enli Studio and ShangART Gallery
Asian private collector

水

油畫畫布
300 x 250 厘米
特別鳴謝：張恩利工作室及香格納畫廊
亞洲私人藏家

Water　2014

Oil on canvas
300 x 250 cm
Courtesy of Zhang Enli Studio and ShangART Gallery
Asian private collector

水（2015/2 號）

油畫畫布
250 x 400 厘米
特別鳴謝：張恩利工作室及香格納畫廊
亞洲私人藏家

Water (2015/No. 2)

Oil on canvas
250 x 400 cm
Courtesy of Zhang Enli Studio and ShangART Gallery
Asian private collector

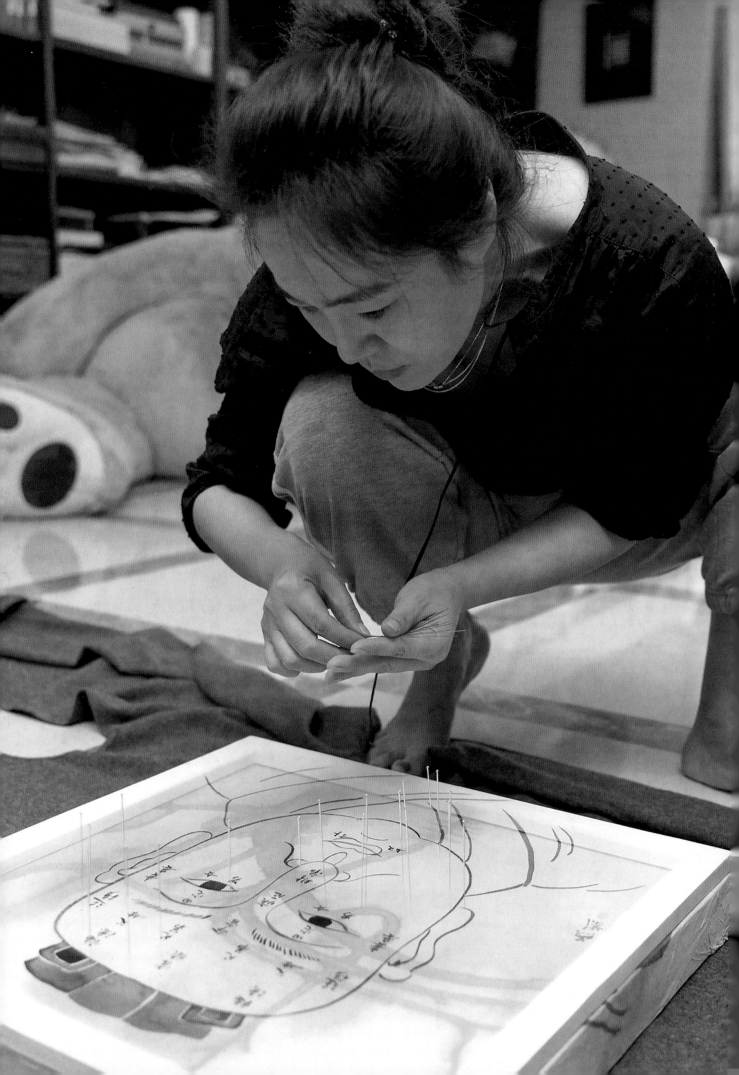

章燕紫
ZHANG YANZI

1967 / 江蘇 / JIANGSU

章燕紫畢業於北京中央美術學院，現生活、居住在北京，並擔任中央美術學院實驗藝術學院教授。她以具備獨特風格的作品，在悠久的中國歷史文化與多變的當代藝術之間建起了一座橋，既尋求在和諧恬靜的古典風格藝術中緩和內心的不安，也探討當代社會的各種問題。

Zhang Yanzi graduated from the Central Academy of Fine Arts (CAFA) in Beijing, and currently lives and works in Beijing as a Professor at CAFA. Zhang's unique style builds a bridge between the long tides of Chinese history and culture and the swiftly changing currents of contemporary art. Through her art, she seeks solace from inner anxieties in the harmonious and tranquil style of classical art, while simultaneously addressing issues of contemporary society.

近年參與國際展覽（部分）

個展
2019 「荷爾蒙」，墨爾本 The Victorian Artists Society

聯展
2022 「第十四屆達卡非洲當代藝術雙年展」，塞內加爾黑人文明博物館
「食之道」，澳大利亞新州博物館
2021 「墨城」當代藝術展覽，香港大館當代美術館
2020 「Breakout」，紐約 Ethan Cohen 畫廊

SELECTED EXHIBITIONS

SOLO EXHIBITIONS
2019 *Hormones: Zhang Yanzi Solo Exhibition*, The Victorian Artists Society, Melbourne, Australia

GROUP EXHIBITIONS
2022 *14th Dakar Biennale of African Contemporary Art*, the Museum of Black Civilizations in Dakar, Senegal
The Way We Eat, Art Gallery of New South Wales, Sydney, Australia
2021 *"INK CITY" Contemporary Art Exhibition*, Tai Kwun Contemporary, Hong Kong, China
2020 *Breakout*, Ethan Cohen Gallery, New York, USA

在過去的作品中，我試圖去解決一些問題，關於「痛」，關於「治」，關於「麻醉」，比如《止痛貼》系列、《透氣》、《至樂無樂》等。但是，《她的 24 章節》不同於以往，這件作品裏，我不想去解決任何問題，而是嘗試用中國傳統文化中「二十四節氣」的概念去對應「她」的一生：從孕育在母體裏小小的「立春」，經歷細雨春風，大暑大寒，跌宕起伏，到歸於平靜，每一個章節都好似很平凡，卻以最平實的方式和視角記錄了一個女人的一生。

在創作中，我像在做拼圖一樣，從生活裏、記憶裏搜索各種適合的碎片，拼拼湊湊連綴成一根長長的線。二十四個片段，每一個既獨立，又有聯繫，我沒有考慮風格、手段的統一，沒有考慮這是不是水墨作品，也沒有考慮這是不是藝術。我似乎只想把一個故事說完。

這組作品開始於 2021 年，我在吃草莓和桑葚的時候，對女性身體與日常蔬果食材之間突然產生了「鏈接」的通感，創作了「春分」和「秋分」兩件作品。這種突發靈感的作品做起來會很輕鬆，很多時候它們出自某種直覺，很難描述，忽然就出現，抓住就行了。後來我心心念念想把二十四節氣都做完，這等於是給自己出了一個難題，這就是我所說的「限制」。

我給自己的「限制」是，用女人一生的二十四個階段去對應二十四節氣，並且用最常見的水果蔬菜去達到一種「會意」的表達。正如前面所說，這件作品有點像做一個拼圖，或是搭一個火車積木，拼着拼着，總有一些東西找不着，一些空缺怎麼也填不上。這讓我經常陷入困境，甚至幾度想放棄，不過，最後還是堅持完成了。

在這個被自己「限制」的過程中，我體會到自己折磨自己的滋味，也體會到不能擴張只能深入的樂趣。

我想，「天高任鳥飛」和「螺螄殼裏做道場」也許殊途同歸。

Artwork

In my previous works, such as *The Remedy*, *The Breathable*, and *Perfect Enjoyment Is to Be Without Enjoyment*, I strive to address issues such as "pain," "treatment," and "anesthesia." In the present work, *Her 24 Solar Terms*, however, my quest is not to resolve any problems but to correspond to my comprehension of the "24 Solar Terms" in traditional Chinese culture in *Her* life. From Spring Commences representing women's conception, the drizzle and spring breeze to the fluctuating Great Heat and Severe Cold and subsequently back to normal, each seemingly mundane chapter documents the life of a woman in a simplistic manner.

I searched for fragments in life and from my memory beneficial to the creative process. It was like solving a jigsaw puzzle, whereby I pieced the bits and pieces together to form a long line. Each of the 24 fragments is independent yet connected. I did not think about the unity of style and manoeuver, neither did I bother to consider whether it was an ink-wash painting or it was an artwork. I guess I just wanted to finish telling a story.

My creation of this series of work started in 2021. While eating strawberries and mulberries, I instantaneously felt the "connection" between female bodies and fruits and vegetables. That gave birth to two of my works, *Spring Equinox* and *Autumn Equinox*. Unexpected inspiration like this makes it all effortless. Inspiration often comes from intuition, and that experience is beyond words. Ideas just pop up and things will work as long as I catch up with the ideas. After a while the idea of completing all of the "24 Solar Terms" lingered on, which turned out to be a self-inflicted problem which I called "restriction."

Such a "restriction" I imposed on myself was to use the 24 phases of a woman's life to represent the "24 Solar Terms," while the most common fruits and vegetables were portrayed as a tacit nuance. As mentioned earlier, this effort is like solving a jigsaw puzzle or building a toy train out of blocks when there are always objects that can't be found and voids that cannot be filled. I often became so frustrated that I almost wanted to give up a few times, but I managed to forge ahead and completed the work.

During the course of being "restricted" by myself, I experienced self-torture but also the joy of digging deep as there was no other way around it.

I think, freedom and restriction are two sides of the same coin.

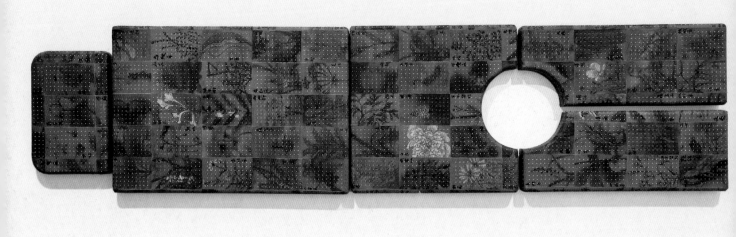

宮

止痛貼、水墨
30 x 20 厘米；42 x 62 厘米；42 x 43 厘米；20 x 52
厘米；20 x 52 厘米
特別鳴謝：方由及藝術家

Sanctuary

2016

Ink on analgesic plasters
30 x 20 cm; 42 x 62 cm; 42 x 43 cm; 20 x 52 cm; 20 x 52 cm
Courtesy of Ora-Ora & the artist

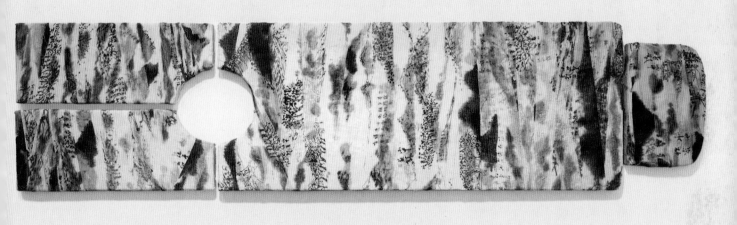

痕

紗布、水墨
30 x 20 厘米；42 x 62 厘米；42 x 43 厘米；20 x 52
厘米；20 x 52 厘米
特別鳴謝：方由及藝術家

Scar

2016

Ink on gauze bandages
30 x 20 cm; 42 x 62 cm; 42 x 43 cm; 20 x 52 cm; 20 x 52 cm
Courtesy of Ora-Ora & the artist

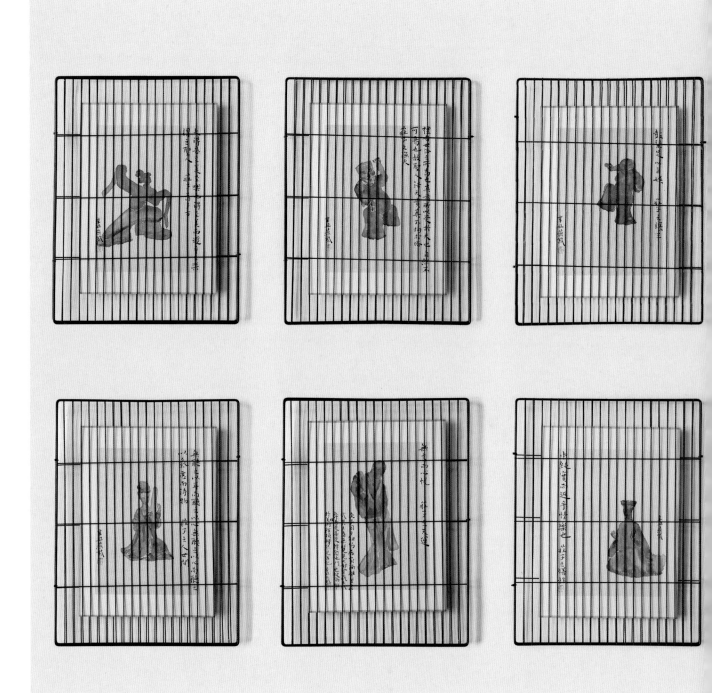

至樂無樂

設色紙本、鐵柵欄
45 x 35 厘米 x 12
特別鳴謝：方由及藝術家

Perfect Enjoyment Is to Be Without Enjoyment　2021

Ink and colour on paper, metal racks
35 x 45 cm x 12
Courtesy of Ora-Ora & the artist

她的 24 章節
Her 24 Solar Terms

2022

立春 Spring Commences

綜合媒材 Mixed media
30 x 30 厘米 30 x 30 cm

雨水 Spring Showers

綜合媒材 Mixed media
40 x 30 厘米 40 x 30 cm

驚蟄 Insects Waken

綜合媒材 Mixed media
40 x 30 厘米 40 x 30 cm

春分 Vernal Equinox

綜合媒材 Mixed media
60 x 42 厘米 60 x 42 cm

特別鳴謝：章燕紫工作室
Courtesy of Zhang Yanzi Studio

清明　**Bright and Clear**

綜合媒材　Mixed media
24 x 30 厘米　24 x 30 cm

穀雨　**Corn Rain**

綜合媒材　Mixed media
34 x 25 厘米　34 x 25 cm

立夏　**Summer Commences**

綜合媒材　Mixed media
75 x 45 厘米　75 x 45 cm

小滿　**Corn Forms**

綜合媒材　Mixed media
60 x 60 厘米　60 x 60 cm

芒種　　**Corn on Ear**

綜合媒材　　Mixed media
84 x 28 厘米　　84 x 28 cm

夏至　　**Summer Solstice**

綜合媒材　　Mixed media
98 x 98 厘米　　98 x 98 cm

小暑　　**Moderate Heat**

綜合媒材　　Mixed media
60 x 60 厘米　　60 x 60 cm

大暑　　**Great Heat**

綜合媒材　　Mixed media
80 x 60 厘米　　80 x 60 cm

特別鳴謝：章燕紫工作室
Courtesy of Zhang Yanzi Studio

立秋　**Autumn Commences**

綜合媒材　Mixed media
60 x 80 厘米　60 x 80 cm

處暑　**End of Heat**

綜合媒材　Mixed media
60 x 37 厘米　60 x 37 cm

白露　**White Dew**

綜合媒材　Mixed media
24 x 30 厘米　24 x 30 cm

秋分　**Autumnal Equinox**

綜合媒材　Mixed media
60 x 42 厘米　60 x 42 cm

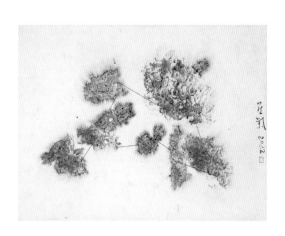

寒露　　　**Cold Dew**

綜合媒材　　Mixed media
30 x 40 厘米　30 x 40 cm

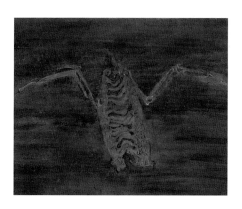

霜降　　　**Frost**

綜合媒材　　Mixed media
24 x 30 厘米　24 x 30 cm

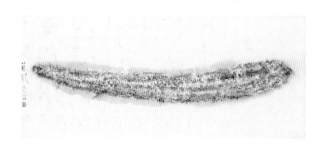

立冬　　　**Winter Commences**

綜合媒材　　Mixed media
25 x 60 厘米　25 x 60 cm

小雪　　　**Light Snow**

綜合媒材　　Mixed media
32 x 32 厘米　32 x 32 cm

特別鳴謝：章燕紫工作室
Courtesy of Zhang Yanzi Studio

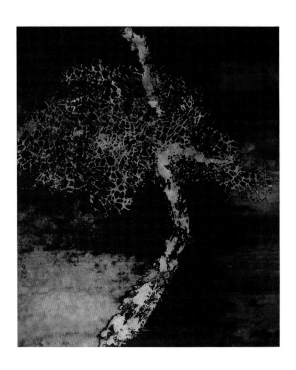

大雪　　**Heavy Snow**

綜合媒材　　Mixed media
60 x 50 厘米　　60 x 50 cm

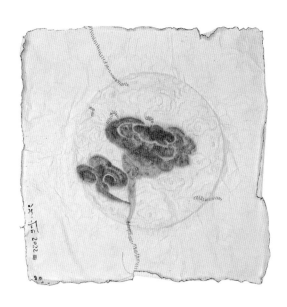

冬至　　**Winter Solstices**

綜合媒材　　Mixed media
50 x 50 厘米　　50 x 50 cm

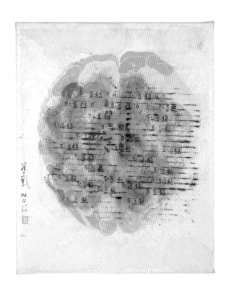

小寒　　**Moderate Cold**

綜合媒材　　Mixed media
30 x 24 厘米　　30 x 24 cm

大寒　　**Severe Cold**

綜合媒材　　Mixed media
57 x 50 厘米　　57 x 50 cm

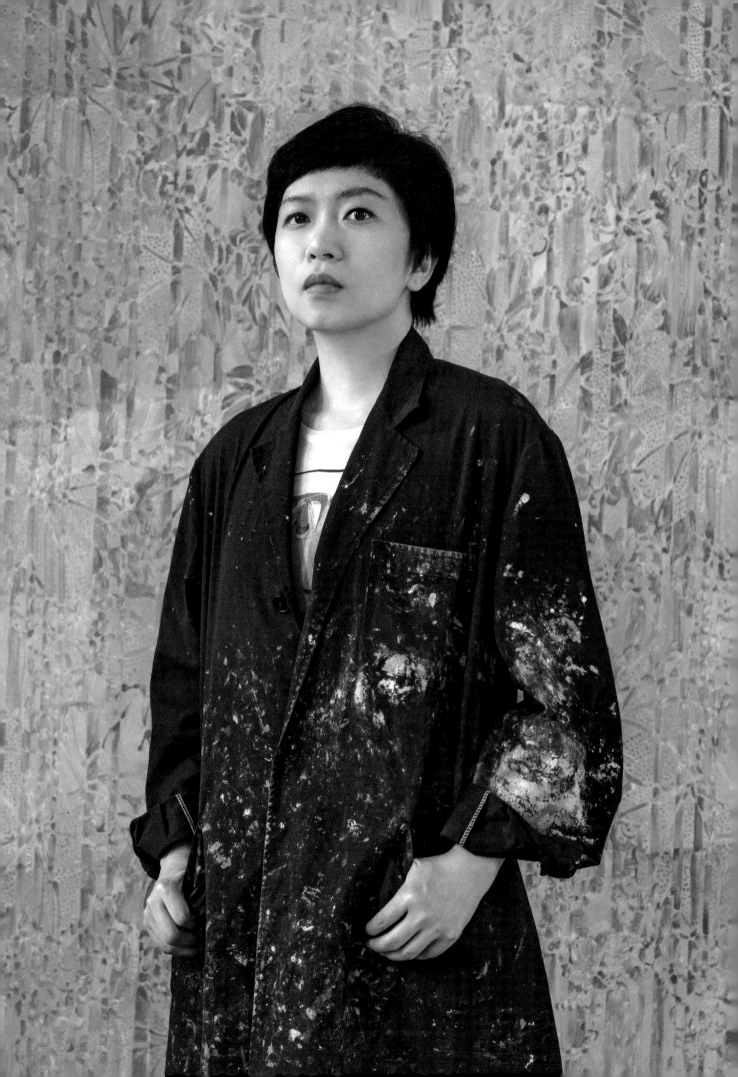

梁遠葦
LIANG YUANWEI

1977 / 西安 / XI'AN

梁遠葦 1977 年生於西安，現於北京工作和生活。她於中央美術學院畢業，先後獲得學士和碩士學位，是新一代藝術家中重要的繪畫實踐者之一。

Liang Yuanwei, born in Xi'an, China in 1977, currently works and lives in Beijing. She received her BA and MA from the China Central Academy of Fine Arts, and has established herself as one of the most renowned artists of the present generation.

近年參與國際展覽（部分）

個展

2019 「一物 OBJECTS：梁遠葦個展」，長沙湖南博物院
2017 「勘玉釧」，威尼斯披撒尼宮 K11 Art Foundation
2015 「橢圓」，西安 OCAT 當代藝術中心
2010 「51 平方：15＃梁遠葦」，北京泰康空間

SELECTED EXHIBITIONS

SOLO EXHIBITIONS

2019 *One Object*, Hunan Museum, Changsha, China
2017 *Behind the Curtains*, K11 Art Foundation at Palazzo Pisani, Venice, Italy
2015 *OVAL*, Xi'an OCAT, Xi'an, China
2010 *51m2: 15# Liang Yuanwei*, Taikang Space, Beijing, China

2017 系列是藝術家梁遠葦自 2015 年的「橢圓」系列後深入推進的作品，在此其間，她不斷推進着筆法經驗，更進一步地將理智與感性相結合。在她發覺自己實踐了多年的分段式繪畫方法與義大利文藝復興早期的濕壁畫技法不謀而合後，梁遠葦在 2016 年前往義大利進修壁畫修復的課題，而文藝復興畫家馬薩喬（Masaccio）的一幅濕壁畫的局部也成爲了梁遠葦 2017 系列的起點。在對古文明的不斷探尋中，梁遠葦同時在回溯着個體的經歷，試圖在極其理性的框架中呈現對自我狀態的感知與體察。

一段來自她童年記憶深處的，1984 年某個暴雨初歇的傍晚的畫面細節也在這一過程中逐漸變得清晰起來 —— 她父親穿着布鞋，濺過柏油路上的一灘積水，水面倒映着房屋和藍天。這時清脆的車鈴響起，他的同事從對面騎車過來，與他寒暄了兩句。可見，從雨夜中提煉出記憶色彩，威尼斯劇院內的藍絲絨牆面，與華美的天頂畫交相輝映的文藝復興圖景，以及從中國古代封建女性的悲劇故事中抽離而出卻又當下交疊的性別線索，最終都交匯在梁遠葦於威尼斯創作的《勘玉釧》中。「2017 系列」不僅承載着超越物質性的人文關懷，還呈現了藝術家的創作進程中不斷自然交匯的東西方文明線索。

Artwork

Liang Yuanwei's 2017 Series evolved from her *Oval Series* from 2015. During this period, she continuously refined her techniques and honed her aesthetic vision that combined rationality and sensibility. After coming to the realization that the layering method she had pursued for years echoed the fresco technique of the early Italian Renaissance, Liang ventured to Italy in 2016 to study fresco restoration. While in Italy, a section of a fresco by Italian Renaissance painter Masaccio became the inspiration for Liang's 2017 Series. While exploring ancient civilizations, Liang simultaneously looks inwards to meditate on personal experiences, seeking to present subjective reflections and sensibilities within extreme rational framework.

In the process, a scene from the depths of Liang's childhood memories materialized. The year was 1984, in the evening of the aftermath of a rainstorm. Liang's father, in shoes made of cloth, was sloshing through a puddle on the asphalt road. In the puddle was the reflection of houses and the blue sky beyond. At this moment, the crisp ring of a bike bell sounded out. A colleague of Liang's father rode over from the opposite side of the road and briefly conversed with him. Extracting the colours from this rainy evening scene, Liang concocted *Behind the Curtain* by fusing the dreamy hues from her memory with the blue velvet walls of the Venetian theatres, the luxurious resplendent tableaux of Renaissance ceiling paintings, and the tragic stories of gender oppression experienced by women from ancient China. Weaving a narrative that intertwines the past with present-day contemporary issues, Liang's 2017 Series not only articulates humanistic concerns that transcend materiality but also reveals the artist's fluid manoeuvring of influences from both Eastern and Western civilizations.

2017 no. 10

油彩麻布
250 x 190 厘米
特別鳴謝：藝術家
亞洲私人藏家

2017 no. 10

Oil on linen
250 x 190 cm
Courtesy of the artist
Asian private collection

2017 no. 11

油彩麻布
100 x 80 厘米
特別鳴謝：藝術家
亞洲私人藏家

2017 no. 11

Oil on linen
100 x 80 cm
Courtesy of the artist
Asian private collection

2017

2017 no. 7

油彩麻布
100 x 80 厘米
特別鳴謝：藝術家
亞洲私人藏家

2017 no. 7

Oil on linen
100 x 80 cm
Courtesy of the artist
Asian private collection

2017 no. 26

油彩麻布
190 x 160 厘米
特別鳴謝：藝術家
亞洲私人藏家

2017 no. 26

Oil on linen
190 x 160 cm
Courtesy of the artist
Asian private collection

2017

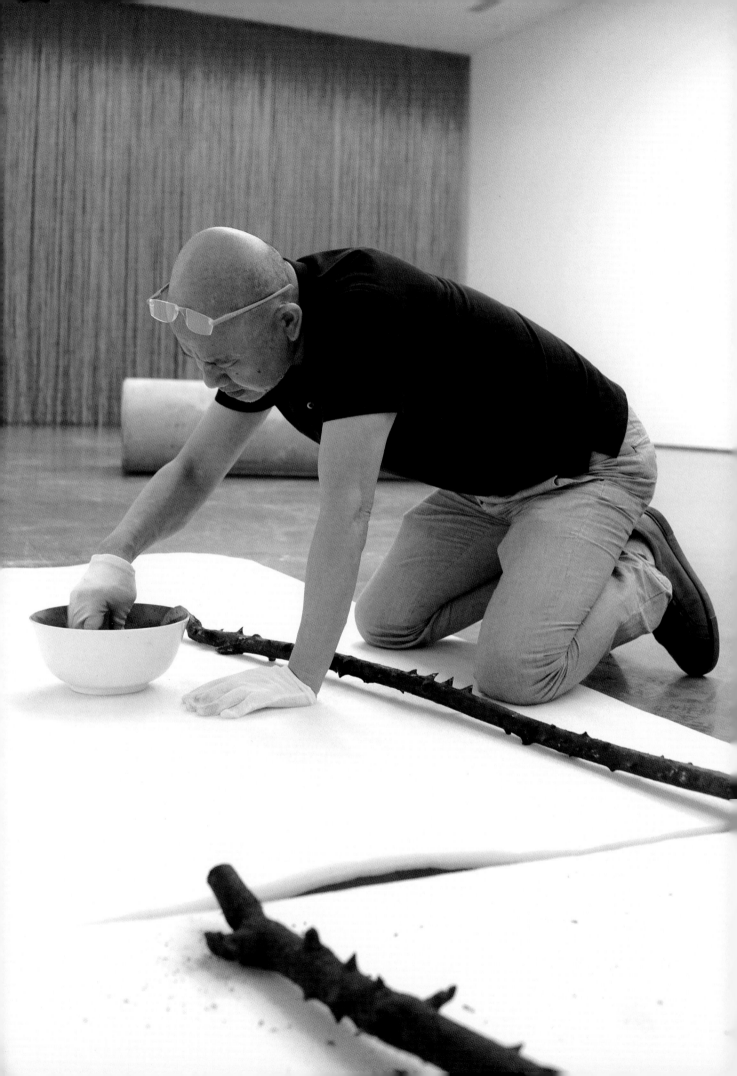

劉建華
LIU JIANHUA

1962 / 江西 / JIANGXI

劉建華生於中國江西。他早期系列代表作選取中國典型的符號作爲基本創作元素，後期創作的系列令人聯想起宋瓷。藝術家於作品中加入不同的細節，將它們與強調使用基本點、線、面、塊的西方式抽象或極簡區別開來。

Liu Jianhua was born in Jiangxi, China. His early works employed iconic Chinese symbols as fundamental motifs, while his subsequent creations remind audiences of Song ceramics from China. In these works, Liu injects various details to differentiate his art from the formal simplicity of Western abstraction and Western minimalism.

近年參與國際展覽（部分）

個展

2022 「劉建華：形而上器」，上海復星藝術中心
2019 「1342°C ── 劉建華作品」，深圳 OCAT 當代藝術中心
2018 「劉建華：紀念碑」，那不勒斯 Made in Cloister 基金會
　　　「劉建華：物鏡」，上海玻璃博物館
2014 「政純辦！」，紐約皇后美術館

SELECTED EXHIBITIONS

SOLO EXHIBITIONS

2022 *Metaphysical Objects*, Fosun Foundation, Shanghai, China
2019 *Liu Jianhua: 1342°C*, OCAT Shenzhen, Shenzhen, China
2018 *Liu Jianhua: Monumenti*, Fondazione Made in Cloister, Naples, Italy
　　　Liu Jianhua: Mirror Effect, Shanghai Museum of Glass, Shanghai, China
2014 *Polit-Sheer-Form!*, Queens Museum, New York, USA

關於作品

《方》

作品《方》通過古老的燒瓷工藝，加以對當今社會的深刻思考與感悟。以古代陶瓷堅硬與脆弱並存的特性隱喻現代人對物質的迷戀與不安，揭示了現今社會特有的精神特徵。

任何作品的創作都是在當下現實社會環境的背景中進行思考和實驗的，當然還有人文線索。從 08 年開始我一直寄望嚮往一種有別於直接和寫實場景的方式進行工作，因為那樣會把觀眾的觀看行為和思考固定在一個簡單的模式上。

純粹性是作品體現的本質。作品呈現的距離感是多樣的，有了距離能使人的思考進行得更深入。簡單的模擬化在此顯得單一和毫無深度。社會發展得如此豐富和急速，但人們一直不知生活在今天的本質是為了甚麼。今天已經沒有環境和空間讓你去追求答案，也永遠不會得到答案，任何生命都是有限的，在有限的時空中只有不斷思考和相對的滿足，這需要智慧。純粹性也來自於人的內心對物質的一種理解和感應。「溫度」存於人的情緒、感應及自然的環境當中，當兩種不同的物質並存在同一空間的氛圍中時，碰撞出的是經過妥協及退讓之後的並置形態。

冷漠的鋼板與金色的液體是兩種通過「火」的過程呈現的不同物質形態。它們的對抗性、矛盾性及依賴性在純粹的形式中得到體現。金色是富貴典雅的象徵，同時與權力並存，在當今現實中更多的是一種欲望的體現。流動中的金色液體置放在冷漠的鋼板上時，它們的碰撞，瞬間能在人的內心留下「刺痛」的痕跡。

藝術家寄希望作品與空間產生一種關係及情緒，人在進入空間後這種形式的感應會影響到觀看方式並對一些事物的判斷和認識產生一種新的可能，且有利於對現實產生一種思考。

鋼板上突然冒出的莫名金色液體，是物質在形成過程中的一個形態，這種形態的升或降也產生在人與人之間的情緒之中。

《沙》

用材料來類比自然現實中的視覺場景，給人產生幻覺感，似乎成了藝術家這件作品語言和形式表達的一部分。但作品的核心指向當然是其內在的思考和觀念。在東方文化形態中，以物擬人的內心感受及狀態始終伴隨作品的精神核心，所有又與現實密不可分。這些用瓷製作的一堆堆沙的形，既虛幻又清晰，既遙遠又現實，給人一種揮之不去的視覺感受和現實思考。

《盈》

作品與中國哲學中對事物的認知產生關聯性，把日常生活和自然規律中觀察到的一些現象變化，轉換到美學形態中去呈現，使人們在視覺體會中去感受哲理與人內心的細微精確，並產生多維的思考。

Artwork

Square

All the creation of artwork has been gone through the process of thinking and experimentation in the social context of the current reality, and of course, with the process of humanity as well. Since 2008, I have started to work in different styles from the direct and realistic manner as this kind of manner will let the audience look at and think on the works in a fixed simple way.

Purity is the essence of the embodiment of the artworks. The sense of distance that the artwork brings is diverse, and with this sense of distance from the art piece, it leads the audience to a deeper thinking. Mere simulation of the reality simplifies the complexity and makes the artwork looks unsophisticated. Society develops rapidly and bounteously, but for a long time people have not realized what is the essence of living. In today's world, it is not a good environment nor is there any space for people to search for the answer, and even if so, one can never find the answer. Every living being is limited in nature, and in the limited time/space, one can only think constantly and be satisfied in a relative term; and for this, wisdom is highly required. Purity also comes from understanding and the inner sense of human beings towards materiality. "Temperature" is stored in one's emotions, sense and also the natural environment; when two different materials exist in the same atmospheric space at the same time, the collision is the result of the juxtaposed form after the process of compromise and concession.

The cold steel and golden liquid are two types of physical forms presented which have been gone through the process of "fire". Their antagonistic, contradictions and dependency are reflected in a pure form. Gold is the symbol of wealth and elegance, and it co-exists with power usually. And in today's reality, gold is more like a manifestation of desire. The flow of golden liquid was placed on the cold steel, while colliding, it instantly "stings" people's heart.

I wish that relations and emotions could arise in between the works and the space; after one enters the space, the sense of form can affect the way of viewing and also gives way to a new possibility of judging and understanding things; furthermore, it could be conducive to produce a way of thinking towards the reality.

The golden liquid suddenly appearing on the steel plate is a form arising from the process of formation of the matter, and the rise or fall of this form is also a production of the sentiment among people.

Sand

The use of materials to simulate the visual scene in the natural reality, giving people a sense of illusion, seems to be part of the artist's language and formal expression of this work. But the core of the work is its internal thinking. In the eastern cultural form, the inner feelings and states of materiality and personification are always accompanied by the spiritual core of the works, which are inseparable from the reality. The shapes of these piles of sand that made of porcelain are both illusory and clear, both distant and realistic, giving people a lingering visual feeling and realistic thinking.

Filled

Filled is closely related to Chinese philosophical concepts. It catches the subtle transformations in the nature and in our daily life, and presents them with means of the aesthetics. My intention was to encourage people to experience the precision of philosophy and human nature, and thus to inspire thoughts in multiple dimensions.

方 **Square** 2012-2014

瓷、鋼 Porcelain, Steel
74 x 74 x 3 厘米（每件） 74 x 74 x 3 cm (each)
特別鳴謝：劉建華工作室 Courtesy of Liu Jianhua Studio

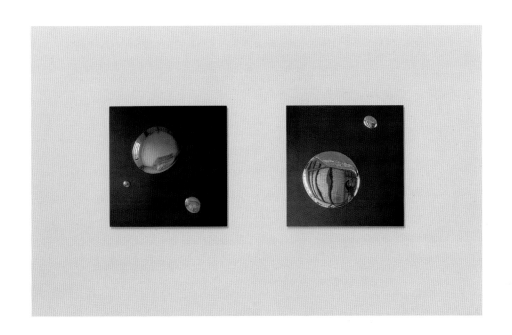

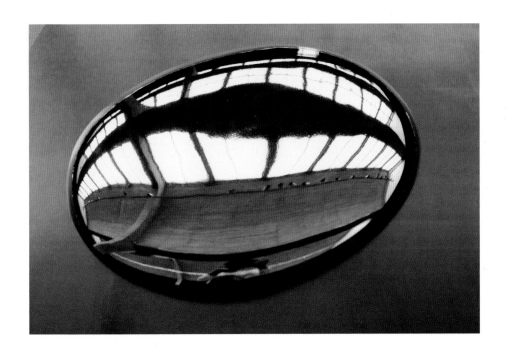

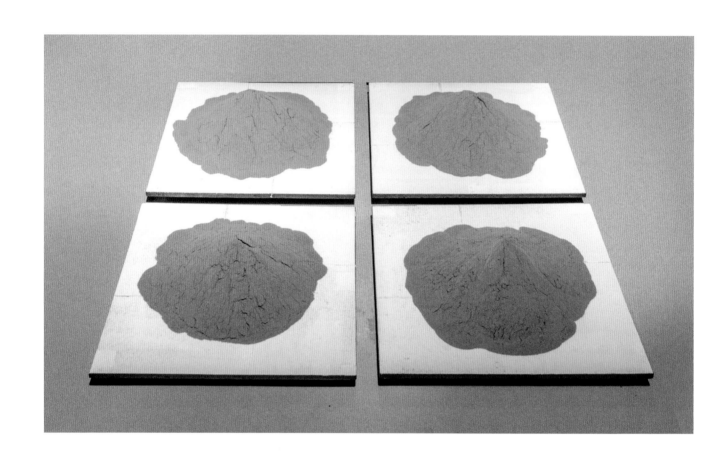

沙

陶瓷、耐火材料
64 x 64 x 20 厘米（每件）
圖片鳴謝：劉建華工作室

Sand

2012-2019

Ceramic, Fire-proof material
64 x 64 x20 cm (each)
Photo courtesy of Liu Jianhua Studio

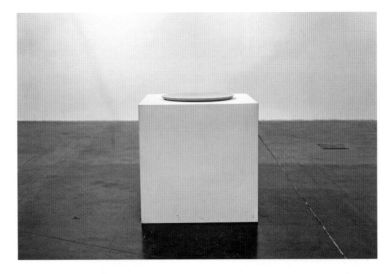

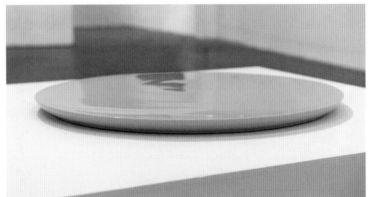

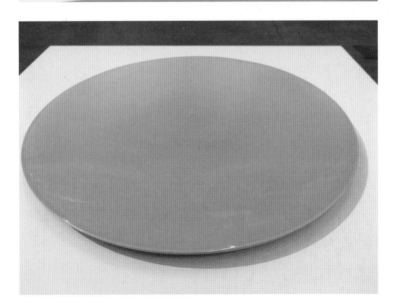

盈

瓷
68 x 68 x 3.5 厘米
圖片鳴謝：劉建華工作室

Filled

Porcelain
68 x 68 x 3.5 cm
Photo courtesy of Liu Jianhua Studio

2015-2017

謝曉澤
XIE XIAOZE

1966 / 廣東 / GUANGDONG

謝曉澤畢業於北京清華大學、北京中央工藝美術學院（現爲清華大學美術學院）和美國北德克薩斯大學。2009 年至今擔任美國加州史丹福大學藝術與藝術史系 Paul L. & Phyllis Wattis 講席教授，現於當地居住及工作。

謝曉澤的作品涵蓋油畫、水墨、影像和裝置，通過對書籍、報紙、文本、檔案等的圖像描繪，探討歷史和記憶之間的關係，關注知識和訊息在人類歷史傳遞過程中的偶然性和碎片特徵。

Xie Xiaoze graduated from Tsinghua University, Beijing, Central Academy of Arts and Design, Beijing (currently Academy of Arts & Design, Tsinghua University), and University of North Texas, Texas. He is the Paul L. & Phyllis Wattis Professor of Art at Stanford University in California since 2009. Xie lives and works in California, USA.

Xie's oeuvre include oil painting, ink-wash painting, video and installation, exploring the relationship between history and memory through visual representation of books, newspapers, texts, archives, etc., as well as looking into the contingency and fragmentation of knowledge and information during the course of human history transmission.

近年參與國際展覽（部分）

個展
2019-20 「謝曉澤：物證」，紐約亞洲協會博物館
2017-18 「注視：謝曉澤」，科羅拉多州丹佛美術館
聯展
2019 「水墨現在：第十屆深圳國際水墨雙年展」，深圳畫院、深圳 OCAT 當代藝術中心、華美術館
2017-18 「安仁雙年展──今日之往昔」，四川安仁古鎮
2016 「蕭條與供給──第三屆南京國際美術展」（獲繪畫學術獎），南京百家湖美術館

SELECTED EXHIBITIONS

SOLO EXHIBITIONS
2019-20 *Xiaoze Xie: Objects of Evidence*, Asia Society Museum, New York, USA
2017-18 *Eyes On: Xiaoze Xie*, Denver Art Museum, Denver, Colorado, USA
GROUP EXHIBITIONS
2019 *Ink at Current: 10th International Ink Art Biennial of Shenzhen*, Shenzhen Fine Art Institute, OCAT Shenzhen, OCT Art & Design Gallery, Shenzhen, China
2017-18 *Anren Biennale: Today's Yesterday*, Anren, Sichuan, China
2016 *HISTORICODE: Scarcity & Supply/The 3rd Nanjing International Art Festival*, Baijia Lake Museum, Nanjing, China (Winner of Academic Award in Painting)

是次展出作品靈感來自我 2017、2018 年在敦煌研究院駐地創作的構思。當時的水墨長卷《歷史的琥珀：敦煌藏經洞的再想像》圍繞藏經洞獨特的歷史和百科全書式的內容展開，根據測繪圖把藏經洞內部空間轉換爲一個實體，在其內部投射各種想像。

敦煌藏經洞系列中，《觀乎天文，以察時變》和兩幅相關習作《占星、占雲、九州分野》、《占星、占雲、十二分野》主要來源於英藏敦煌文獻《全天星圖》。占星、占雲和分野之術三位一體，是古人預測未來、判斷吉凶的重要手段。我按照「天圓地方」的說法，把《全天星圖》十三張平面星圖按照空間關係組合成爲一個半球體，作爲天穹覆蓋着由九州或十二古國組成的分野地圖；又引用唐《占雲氣書一卷》的雲氣形態，懸浮於天穹和大地之間。天穹或包含於藏經洞內，或從外部覆蓋着藏經洞，共同構成一個世界模型，完整體現了中國古代這一獨特的文化現象和信仰知識系統。

《佛教寰宇》以法藏唐代《三界九地之圖》爲藍本，參考《阿毗達磨俱舍論》關於佛教宇宙觀的文字論述，建構了立體模型，置藏經洞內，契合「一窟之內，宛然三界」的含義。而《東西方寰宇圖》則並置了佛教宇宙結構和但丁《神曲》中地獄、煉獄、天堂的嚴整層次，徵引中西方藝術中對於生死主題的不同表達，表現人類共同的痛苦、掙扎和對天堂幸福的嚮往，並以此尋求中西方文化的對話、呼應、折衷和轉換。

Artwork

The works on display are inspired by my artist residencies at the Dunhuang Academy in 2017 and 2018, where I created a series of ink and brush scroll drawings titled *Amber of History: Re-Imaginations of the Library Cave in Dunhuang*. It revolved around the Library Cave's unique history and encyclopaedic contents, transforming the interior space of the Library Cave into a solid volume and projecting various visions onto its interior.

Astronomy and Astrology and two related drawings *Astronomy and Astrology Study No.1* and *Astronomy and Astrology Study No.2* are mainly derived from the *Dunhuang Star Atlas* in the *Chinese Manuscripts Acquired from Dunhuang* by Aurel Stein. The ancients predicted the future and fortunes by observing stars and clouds as well as correlating stars with states. According to the saying "the sky is round, and the 7earth is square (*tian yuan di fang*)", I combined the thirteen flat star maps of the *Dunhuang Star Atlas* into a hemisphere according to the spatial relationship, and used the hemisphere as the sky dome covering the nine ancient states or twelve ancient countries. Between the sky and the earth, I devised clouds floating in the sky as in *Volume 1 of Book on Cloud and Aura Divination (Zhan yunqi shu yi juan)*, which was compiled in the *Tang* Dynasty. The dome of the sky is either encompassing or contained inside the Library Cave. Together they constitute a model of the world, which fully embodies the unique cultural phenomenon of ancient China and its systems of knowledge and belief.

The work *Buddhist Cosmology Study* is based on the *Picture of Trailokya and Nine Lands (San jie jiu di zhi tu)*, created in the *Tang* Dynasty and now held in the National Library of France. It formed a three-dimensional model inside the Library Cave, representing "three realms inside one cave", echoing the Buddhist cosmology described in *Commentary on the Sheath of Abhidharmakośa* And *Eastern and Western Cosmologies* juxtaposes the Buddhist cosmological structure and the strict hierarchy of hell, purgatory and heaven in Dante's *The Divine Comedy*, citing the different expressions of life and death in Eastern and Western arts. It demonstrates the familiar pain, struggle, and happiness of human beings and their yearning for heaven. In this triptych, Eastern and Western cultures are in dialogue and resonate with each other, blended and transformed in such unique juxtapositions.

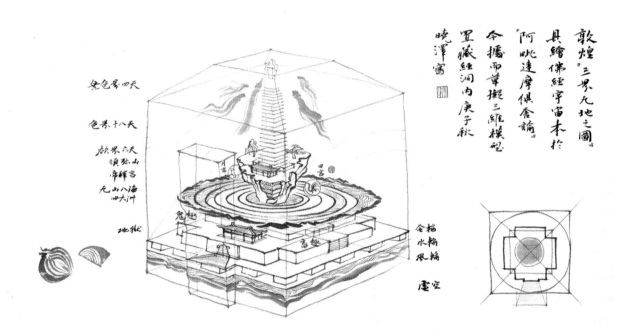

無色界四天

色界十八天

欲界六天
須彌山
帝釋宮
无山八海
四大洲

地獄

鬼趣

畜趣

金輪
水輪
風輪

虛空

敦煌「三界九地之圖」
具繪佛經宇宙本於
「阿毗達摩俱舍論」
今攜而草擬三維模型
置藏紅洞內庚子秋
曉澤寫

佛教寰宇
（敦煌藏經洞系列）

水墨紙本
45 x 95 厘米
特別鳴謝：善盈藝術收藏

Buddhist Cosmology Study
(from the Dunhuang Library Cave Series)

2021

Ink on Xuan paper
45 x 95 cm
Courtesy of Michael & Saniza Collection

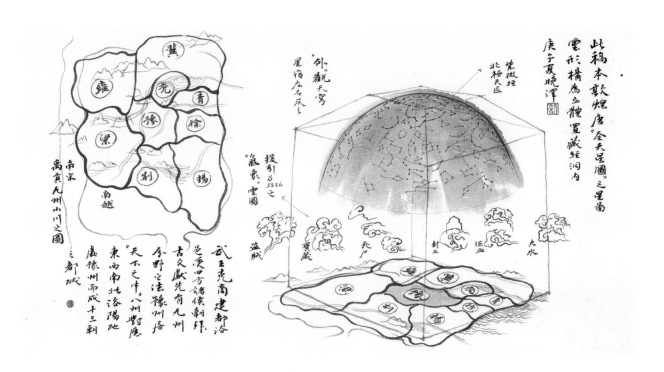

**占星、占雲、九州分野
（敦煌藏經洞系列）**

**Astronomy and Astrology Study No.1
(from the Dunhuang Library Cave Series)**

2021

水墨紙本
45 x 95 厘米
特別鳴謝：善盈藝術收藏

Ink on Xuan paper
45 x 95 cm
Courtesy of Michael & Saniza Collection

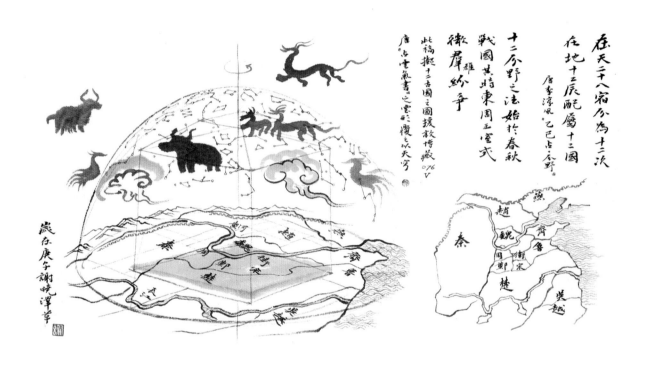

在天二十八宿分為十二次

在地十二辰配屬十二國

唐李淳風乙巳占分野曲

十二分野之法始於春秋

戰國其時東周王室式

徵羣雄紛爭

此稿擬十古圖之圖援敦博藏076 V

廣占雲氣書之雲彩復之以天穹

歲在庚子謝曉澤寫

燕
趙
齊
魯
衛宋
秦
魏
鄭
周
楚
吳越

占星、占雲、十二分野 （敦煌藏經洞系列）

水墨紙本
51 x 95 厘米
特別鳴謝：善盈藝術收藏

Astronomy and Astrology Study No.2 (from the Dunhuang Library Cave Series)

2021

Ink on Xuan paper
51 x 95 cm
Courtesy of Michael & Saniza Collection

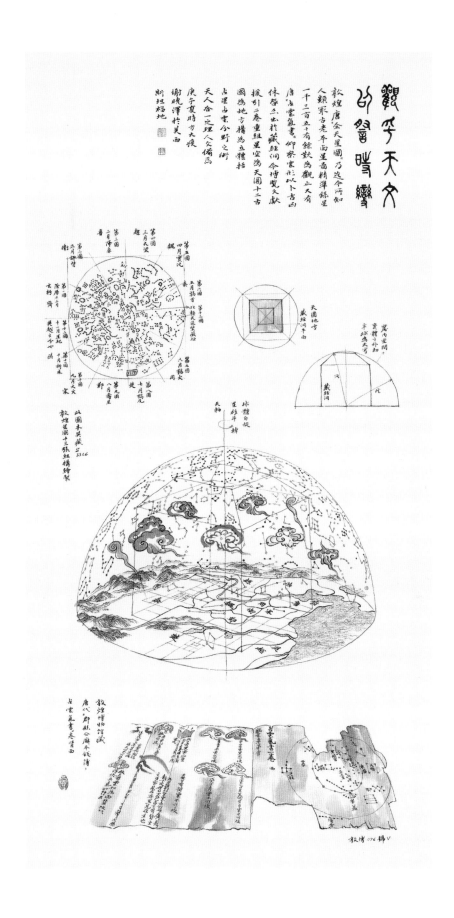

觀乎天文，以察時變
（敦煌藏經洞系列）

水墨紙本
178 x 76 厘米
特別鳴謝：善盈藝術收藏

Astronomy and Astrology
(from the Dunhuang Library Cave Series)

2021

Ink on Xuan paper
178 x 76 cm
Courtesy of Michael & Saniza Collection

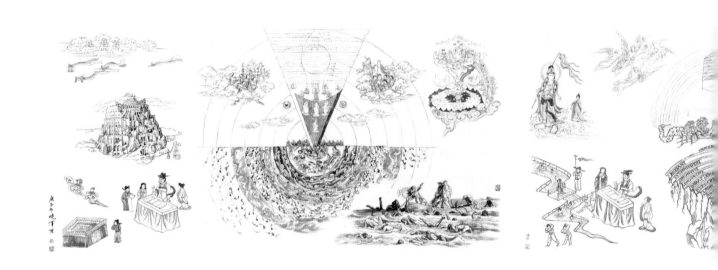

東西方寰宇圖

水墨紙本
123 x 245 厘米 x 3
特別鳴謝：謝曉澤工作室

Eastern and Western Cosmologies 2020

Ink on Xuan paper
123 x 245 cm x 3
Courtesy of Xiaoze Xie Studio

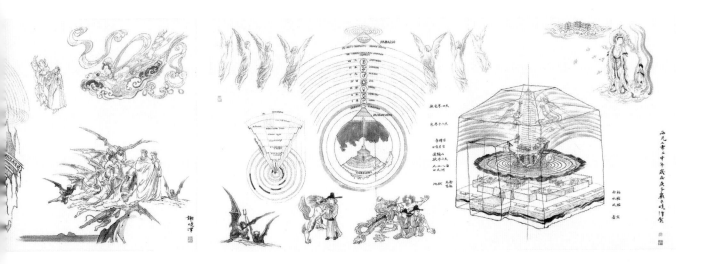

現代藝術大師
MASTERS OF
MODERN CHINESE ARTS

吳冠中
WU GUANZHONG

現代藝術大師

MASTERS OF MODERN
CHINESE ARTS

吳冠中，江蘇宜興人，著名畫家、美術教育家。他早年留學法國，後成為首位獲選法蘭西學院藝術院通訊院士的中國籍藝術家。他的創作力圖把歐洲油畫描繪自然的直觀生動性、油畫色彩的豐富細膩性與中國傳統藝術精神、審美理想融合到一起。從 1970 年代起，吳冠中漸漸兼事中國畫創作，運用中國傳統材料工具表現現代精神，並探求中國畫的革新。

Wu Guanzhong was born in Yixing County, Jiangsu Province. He is a highly respected painter and art educator. He studied in France in his early years, and later became the first Chinese artist being elected Correspondant of the Académie des Beaux-Arts de l'Institut de France. In his artistic creation, Wu incorporated the intuitive and resplendent approach in European landscape paintings with the traditional Chinese artistic spirit and aesthetic ideal. His style gradually evolved over the 1970s, during which time he forayed into the realm of Chinese painting. He manifested modernism with traditional Chinese media, exploring the possibility of revolutionising Chinese paintings.

關於作品

吳冠中憑着別樹一幟的藝術理念，在當今藝壇上備受尊崇。這件作品描繪的是他北京什剎海寓所附近的雪景。當時的中國社會正處於重要變革時期，畫作所表現的冬日雪景也多了一些綠色的生機。

Artwork

Wu Guanzhong was highly respected and recognised for his unique artistic approach and philosophy. This work is a depiction of a snow scene near Wu's residence in Shishahai Lake in Beijing. Executed during a period when the Chinese society was welcoming social reform, *Winter Snow* also exhibits heightened vitality through its depiction of spirited greenery.

冬雪

水墨設色紙本
79 x 69 厘米

Winter Snow

Ink and colour on paper
79 x 69 cm

1978

林風眠
LIN FENGMIAN

現代藝術大師

MASTERS OF MODERN
CHINESE ARTS

林風眠，廣東梅州人，畢業於法國巴黎國立高等美術學院，中國近現代著名畫家、藝術教育家。他曾出任國立北平藝術專科學校（現北京中央美術學院）校長，亦是杭州國立藝術院（中國美術學院前身）首任院長。林風眠力主融合中西繪畫的優點，用西方藝術的現代主義風格探索發展新的中國藝術之路。作品以風景、仕女和花鳥爲主，常用明亮的色彩，風格獨特。

Lin Fengmian was born in Meizhou, Guangdong Province. He was a pioneer in modern Chinese art and art education. After graduating from the École nationale supérieure des Beaux-Arts in Paris, France, Lin returned to China and served as professor and president of the National Art School (now the Central Academy of Fine Arts) in Beijing. Later, he presided over the establishment of the Hangzhou National College of Art (now the China Academy of Art), where he then served as the first Dean. He dedicated his whole life to explore the fusion of the best of Chinese and Western arts, attempting to develop a new form of Chinese arts infused with Western modernist elements. His works focus on landscape, female figures, birds, and flowers, with a unique style and bright colours.

關於作品

此幅構圖飽滿、色彩豐富,顯示畫家受到西方尤其是印象派的
影響;而畫中寫意的筆墨,光影層次的運用又不失傳統的熏陶,
是林風眠融合中西、開創中國現代繪畫新面貌及個人獨特風格
的抒情寫意之作。

Artwork

The rich composition and resplendent colours of the present
work reveal influence from Western oil painting, Impressionism in
particular, while the calligraphic brushwork and layered treatment
of light and shadow retain traces of traditional Chinese painting. It is
an exemplary work demonstrating Lin's unique style that integrates
Chinese and Western methods.

花卉

彩墨紙本
66.5 x 69 厘米

Flowers

Ink and colour on paper
66.5 x 69 cm

年份不詳 Year unknown

徐悲鴻
XU BEIHONG

現代藝術大師

MASTERS OF MODERN
CHINESE ARTS

徐悲鴻，江蘇宜興人，中國現代畫家、美術教育家。早年留學法國，後出任北京中央美術學院院長。他的創作理念主張用西方繪畫的寫實技法改革中國畫，並強調藝術的思想內涵，作品以人物、走獸和花鳥為主，其奔馬題材的作品尤其聞名於世。

Xu Beihong was born in Yixing County, Jiangsu Province, and was a pioneer in modern Chinese art and art education. He studied in France in his early years, and was appointed the President of Central Academy of Fine Arts in Beijing. Xu dedicated to reforming Chinese paintings with the realism approach in Western arts, emphasising particularly the ideology behind the arts. His artworks focus on human figures, animals, birds and flowers. His paintings of galloping horses are well known worldwide.

關於作品

喜鵲暗含「喜上眉梢」、「捷報頻傳」等美好心願；松樹是傳統文人筆下具有特定審美意義的情感載體。古有詩云「高松出眾木」，徐悲鴻曾將此幅作品贈予著名抗日愛國將領于學忠，以表達崇高的敬佩之情。

Artwork

The magpie is an important auspicious motif in Chinese painting, representing blessings and well wishes such as *xishang meishao* (happiness up to one's eyebrows) and *jiebao pinchuan* (repeated good news). Meanwhile, the motif of the pine tree is a favourite amongst literati and poets as the saying goes, "the tall pine tree is outstanding among the woods". It has long carried specific aesthetic significance and emotional meaning to scholars and literati. Presenting this work to the renowned patriotic military commander during the resistance against Japan, Yu Xuezhong, Xu conveys utmost levels of admiration and respect.

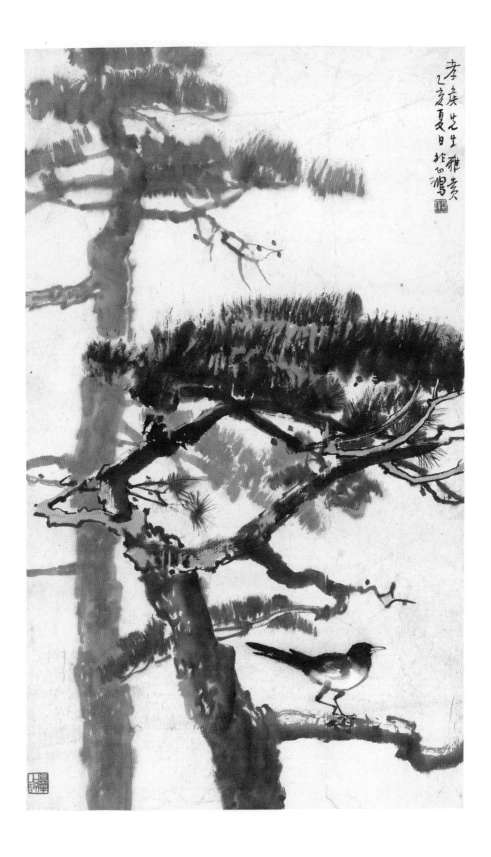

喜鵲 松樹

A Magpie on Pine Tree

水墨設色紙本
130 x 77 厘米

Ink and colour on paper
130 x 77 cm

陳樹人
CHEN SHUREN

現代藝術大師

MASTERS OF MODERN
CHINESE ARTS

陳樹人，廣東番禺人，早年曾拜師居廉門下，又東渡日本求學，先後入京都市立美術工藝學校、京都美術學校攻讀繪畫科，以及東京國立大學文學系研習世界文學，畢業後歸國投身藝術文化事業。其創作尤注寫生，倡導「推陳出新，不規範於古人」，並與高劍父、高奇峯共同開創嶺南畫派，被合稱爲「嶺南三傑」。

Chen Shuren was born in Panyu County, Guangdong Province. He studied under the tutelage of Ju Lian in his early years, and later pursued his studies in Japan. Upon graduation from the Kyoto City University of Arts, the Painting Department of Kyoto Art School and the Literature Department of the University of Tokyo respectively, Chen returned to China and dedicated himself to developing art and culture with a focus on sketching while promoting "be innovative – be free from ancient constraints." He founded the legendary Lingnan School of Painting with Gao Jianfu and Gao Qifeng. Together, the trio was known as *The Three Greats of Lingnan*.

關於作品

此作佈局獨具一格，松枝葉採用淡灰綠色爲主，粗厚穩健的松樹於正中屹立不動，蒼勁有力，在上面棲息的三隻小雀與其父母相對呼應，表達出一家數口歡欣和樂之意。

Artwork

The pine's leaves and branches are executed in pale grey-green tones, while its trunk is thick and robust, conveying strength and stability. The three fledglings look up to their parents aflight in the air, conveying the spirited joy of blissful familial harmony.

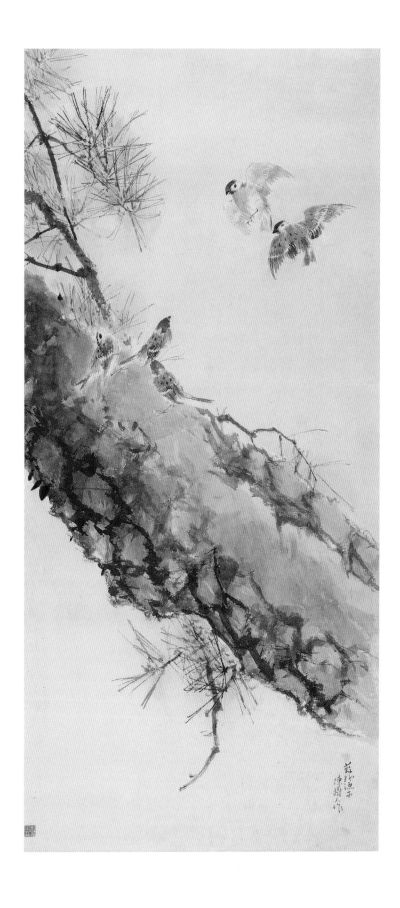

松雀圖

水墨設色紙本
130 x 60.5 厘米

Birds and Pine Tree

Ink and colour on paper
130 x 60.5 cm

20 世紀 40 年代
circa 1940

傅抱石
FU BAOSHI

現代藝術大師

MASTERS OF MODERN CHINESE ARTS

傅抱石，生於江西南昌，二十世紀傑出中國畫家、美術史論家，「新山水畫」代表人物。

早年留學日本，回國後曾執教於南京師範學院、江蘇國畫院等。他的作品以山水、仕女和高士形象爲主，並創「抱石皴」技法，以散鋒亂筆表現山石結構，氣勢磅礴，開拓了中國水墨畫的新風格。

Fu Baoshi was born in Nanchan province, Jiangxi. A respected art historian and a leading figure of the New Landscape Painting movement, he is one of the most preeminent Chinese painters of the 20th century.

Fu studied in Japan in his early years before returning to China to teach at prestigious institutes such as the Nanjing Normal University and the Jiangsu Academy of Chinese Paintings. His notable works feature landscape, ancient female figures, and ancient men. He adopted his very own innovative technique called Baoshi Textured Strokes, which involves using scattered dots and lines in landscape ink painting, pioneering a new style in the genre.

關於作品

這是一件以典型的「抱石皴」繪就的作品，畫中鈐有傅抱石的「往往醉後」印，酣暢淋漓。尺幅雖然不大，但卻極力表現出崇山峻嶺的巍峨之感。

Artwork

This work is representative of Fu's indigenous Baoshi Textured Strokes and is stamped with his seal, "Always After Drinking." Despite its intimate scale, the work powerfully exudes the magnificent grandeur of lofty mountains.

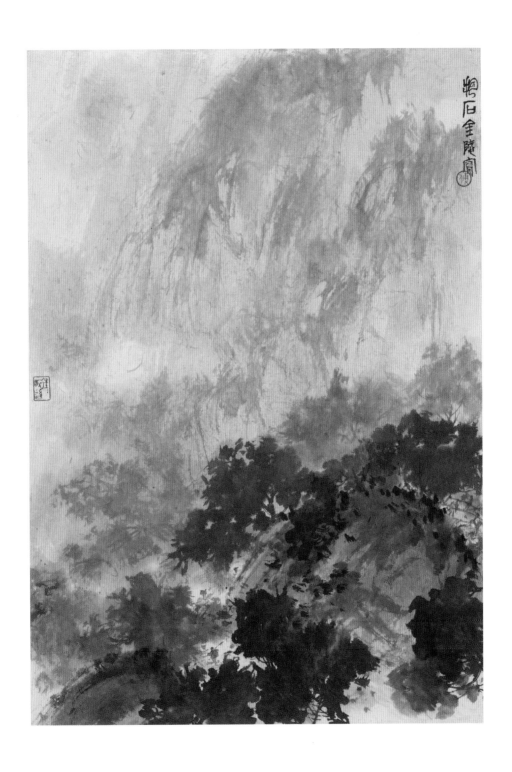

山水

水墨設色紙本
74 x 52 厘米

Landscape

Ink and colour on paper
74 x 52 cm

年份不詳
Year unknown

齊白石 徐悲鴻
QI BAISHI
XU BEIHONG

現代藝術大師
―――――――――――――

MASTERS OF MODERN
CHINESE ARTS

齊白石，湖南湘潭人，中國近現代著名畫家，世界文化名人。曾獲聘中央美術學院名譽教授，1953 年出任中國美術家協會主席，同年獲授予「人民藝術家」稱號，1956 年獲世界和平理事會「國際和平獎金」。其作品以花鳥蟲魚和人物著稱於世，將傳統文人畫的寫意與民間藝術的造型有機結合，有着獨特的藝術風格。

徐悲鴻，江蘇宜興人，中國現代畫家、美術教育家。早年留學法國，後出任北京中央美術學院院長。他的創作理念主張用西方繪畫的寫實技法改革中國畫，並強調藝術的思想內涵，作品以人物、走獸和花鳥爲主，其奔馬題材的作品尤其享名於世。

Qi Baishi was born in Xiangtan, Hunan Province. He was a modern Chinese painter and world-renowned literati. In 1953, he was awarded the title of People's Artist by the Ministry of Culture of the Central Government. Three years later, in 1956, he was awarded the World Peace Prize by the World Peace Council. Flowers, birds, insects, fish, as well as human figures are Qi's most representative subject matters. He developed a unique style and artistic language to combine the traditional literati expressiveness with the form of vernacular arts.

Xu Beihong was born in Yixing County, Jiangsu Province. He was a pioneer in modern Chinese art and art education. He studied in France and was the President of Central Academy of Fine Arts in Beijing. Xu dedicated to reforming Chinese paintings with the realism approach in Western arts, emphasising particularly the ideology behind the arts. His artworks focus on human figures, animals and flowers. His paintings of galloping horses are well known worldwide.

徐悲鴻與齊白石的友誼是二十世紀中國美術史上的一段佳話。

這件作品由徐悲鴻畫竹、石，齊白石補梅，梅花以較低的構圖隱隱藏於竹石之間，表現了齊白石在忘年知己面前的謙虛與感激。這兩人以花中君子爲題，在作品中互爲唱和，相互成就，見證了二人君子莫逆之交的情誼。

The friendship between Xu and Qi is a beautiful story in the 20th century Chinese art history.

This work was jointly created by the two masters: Xu painted the bamboos and stones, and Qi the plum blossoms. The plum blossoms are positioned deferentially between and below the bamboos and stones, demonstrating Qi's humbleness and gratitude to Xu. In this painting, the two of them have sung to each other on the subject of the Four Plants of Virtue (Si Junzi) in Chinese culture, and made a mutual achievement. The work also witnesses their deep friendship.

梅竹

水墨設色紙本
132 x 29 厘米

Plum Blossoms and Bamboo

Ink and colour on paper
132 x 29 cm

1945

主辦單位

紫荊文化集團

BAUHINIA CULTURE GROUP

承辦單位

集古齋

協辦單位

支持單位

古物古蹟辦事處
Antiquities and
Monuments Office

香港中國企業協會
THE HONG KONG CHINESE ENTERPRISES ASSOCIATION

紫荊 雜誌社
Bauhinia Magazine

銀都機構有限公司
Sil-Metropole Organisation Ltd.

香港聯藝機構有限公司
H.K. UNITED ARTS ENTERTAINMENT CO., LTD.

香港文聯
HKL&A

香港書畫文玩協會
Hong Kong Fine Art and Antiques Society

中國对外艺术展览有限公司
China International Exhibition Agency

Loupe

明報月刊

NEW
WORLD
ELITE

美術家

西泠學堂

媒體合作伙伴

鳳凰衛視

明報

橙 新聞 | ORANGE NEWS

古今對話 ｜ 中西互鑒

現當代中國藝術家名品珍賞

主編
焦天龍

出版
中華書局（香港）有限公司
香港北角英皇道 499 號北角工業大廈 1 樓 B
電話：（852）2137 2338
傳真：（852）2713 8202
電子郵件：info@chunghwabook.com.hk
網址：http://www.chunghwabook.com.hk

集古齋
香港中環域多利皇后街 9-10 號中商藝術大廈 4 樓
電話：（852）2526 2388
電子郵件：tsiku@tsikuchai.com

發行
香港聯合書刊物流有限公司
香港新界荃灣德士古道 220-248 號荃灣工業中心 16 樓
電話：（852）2150 2100
傳真：（852）2407 3062
電子郵件：info@suplogistics.com.hk

印刷
美雅印刷製本有限公司
香港觀塘榮業街 6 號海濱工業大廈 4 樓 A 室
電話：（852）2342 0109
傳真：（852）2790 3614

分色
冬青美術製作有限公司
香港柴灣新安街 4 號冠榮中心 8 字樓 A 室
電話：（852）2565 0329
電子郵件：mak@egscan.com.hk

版次
2022 年 11 月初版
©2022 中華書局（香港）有限公司、集古齋

ISBN
978-988-8808-86-1

特別鳴謝
天偉（酒業）國際貿易有限公司

TRADITION AND MODERNITY

Representative Works by
Modern and Contemporary Chinese Artists

CHIEF EDITOR
Tianlong Jiao

PUBLISHER
Chung Hwa Book Co., (H.K.) Ltd.
Flat B, 1/F, North Point Industrial Building,
499 King's Road, North Point, H.K.
Email: info@chunghwabook.com.hk
Website: www.chunghwabook.com.hk

Tsiku Chai Co.,Ltd.
4/F, Chung Sheung Building, 9-10 Queen Victoria Street, Central,
Hong Kong
Tel: (852)2526 2388
Email: tsiku@tsikuchai.com

DISTRIBUTER
SUP Publishing Logistics (H.K.) Ltd.
16/F, Tsuen Wan Industrial Centre,
220-248 Texaco Road, Tsuen Wan, NT, H.K.
Tel: +852-2150-2100/ Fax: +852-2407-3062
Email: info@suplogistics.com.hk

PRINTER
Elegance Printing and Book Binding Co., Ltd.
Block A, 4th Floor, Hoi Bun Building, 6 Wing Yip Street,
Kwun Tung, Kowloon.
Tel: +852-2342-0109/ Fax: +852-2790-3614

COLOUR SEPARATION
Evergreen Colour Management Limited
Unit A, 8/F, Reality Tower, 4 Sun On Street, Chai Wan, Hong Kong
Tel: (852)2565 0329
Email: mak@egscan.com.hk

First Edition, Nov 2022.
©2022 Chung Hwa Book Co., (H.K.) Ltd. & Tsiku Chai Co.,Ltd.

ISBN
978-988-8808-86-1

SPECIAL COURTESY OF
Tin Wai (Fine Wines) International Trading Co., Limited